IMAGES
*of America*

# BRUNSWICK
## THE CITY BY THE SEA

IMAGES
*of America*

# BRUNSWICK
## THE CITY BY THE SEA

Patricia Barefoot

ARCADIA
PUBLISHING

Published by Arcadia Publishing
Charleston SC, Chicago IL, Portsmouth NH, San Francisco CA

Printed in the United States of America

Library of Congress Catalog Card Number: 00-107279

For all general information contact Arcadia Publishing at:
Telephone 843-853-2070
Fax 843-853-0044
E-Mail sales@arcadiapublishing.com
For customer service and orders:
Toll-Free 1-888-313-2665

Visit us on the Internet at www.arcadiapublishing.com

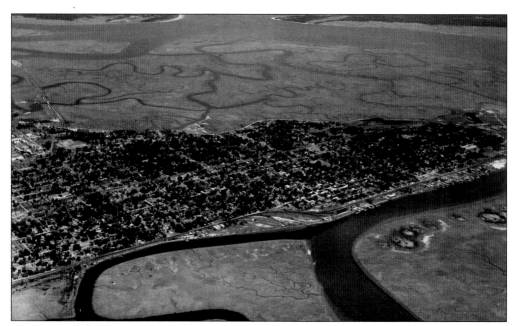

An image of the Brunswick south end peninsula taken in the late 1940s from approximately 4,000 feet provides a stunning view of "The City by the Sea." In the foreground, the East River runs along the waterfront and the layout of Brunswick's planned community demonstrates a heavily forested cityscape. The sinuous sweep of poet Sidney Lanier's famed marshes of Glynn buffer the mainland from the coastal barrier islands (background, left to right) of St. Simons and Jekyll, separated by St. Simons Sound. Notice the winding waterways from the center of the photograph at Clubb Creek, flowing eastward toward its junction with the Back River, and Plantation Creek and Brunswick Point off Jekyll Island's westward approach. (Courtesy of Charles E. Ragland.)

# CONTENTS

# ACKNOWLEDGMENTS

This visual history of Brunswick was conceived through the interest of a regional press. The mission of Arcadia Publishing is to preserve Americana through their *Images of America* series. Chiefly, Ms. Katie White, a patient acquisitions editor, supported this awesome project through her encouragement and tenacity. For those of you who know about the richness of coastal Georgia's history, this book proved an intense, time-consuming labor of love and, in fact, represented a daunting task for a native daughter! How would I portray an enduring vision of Brunswick? I looked to its waterfront, downtown, Old Town's historic structures, and a magnificent garden of great live oaks draped with the ethereal, gray Spanish moss. I recognized how a diversity of people, celebrations, and special commemorative events color the city's proud past. A planned community laid out on the "Oglethorpe Plan" of urban greenspace, parks, and squares, a vastly changed Brunswick posed challenging questions and conflicts and a history rich beyond measure.

 Discussions with my husband, Forrest "Frosty" Barefoot, showed me the way through a morass, friend Harlan Hambright of Crawdad facilitated this work with his genius, and Tom Wallace with his vital computer skills. In support of this gathering of images, Susan Dick and Mandi Dale Johnson of the Georgia Historical Society demonstrated eager assistance, interest, and professionalism. Gini and Richard Steele of Steele Studio in Beaufort, South Carolina, expedited my requests and encouraged this effort. Jim Kammerer, Jane Hildebrand, and Diane Jackson of the Brunswick–Glynn County Regional Library supported, encouraged, and helped along the way. I am indebted to the following people for their interest and generous contributions: Jim Weidhass, public information director of Glynn County Schools; Jim Dryden and Sallie D. Rinear of the *Harbor Sound*; C.H. "Buff" Leavy IV and Bobby Haven of the *Brunswick News*; Darren Harper; and Pat Morris of the Museum of Coastal History. Those who contributed images and family photographs for this visual history have been recognized through courtesy designations, and I am so grateful for your enthusiasm and most of all for your support. Unsung heroes are Betty Jean Thornton, Bob Wyllie, Frances Postell Burns, Mary Frances Gould, Josie Lambright, Catherine Cate, Jane Cate Willis, Jean Hotch, Mary Serra Santos, Circus World Museum's Erin Foley and Fred Dahlinger, Miriam Reyburn Steele, Edward Lowe, Col. Tom Fuller, Jim Cormican Sr., Delores Jones Chapple, Phorestine Appling, Bill Killian, Laurel Breyer, Ernie Craft, Jerry D. Spencer, Joe Parker, Catherine Parker Thompson, Dorothy Paulk McClain, Winona French, Melinda Gunnels, Harry Aiken, Mimi Rogers, Bruce Faircloth, Joyce Knight Blackburn, Woody Woodside, Sarah O. Dunaway, and my benefactors, Harold Hicks and Virginia Hobson Hicks. My ingenious brother Donnie Cofer, and parents, Sam and Marie Cofer, provided me with the education and the "grit" to see a project such as this one to fruition. Without the Tait family's interest—Dorothy and C.S. Tait Jr., to whom I owe an enormous debt of gratitude—this earnest photographic history would have been the less. Bill Brown took time out from family and business to assist with particulars, and how can I ever express sufficient gratitude to Polly Parker Kitchens? Finally, I dedicate this book to my wonderful husband, Forrest "Frosty" Barefoot.

# INTRODUCTION

The book's title, *Brunswick: The City by the Sea*, is based on an intriguing historic document, published by T.G. Stacy and Son in the *Advertiser-Appeal, Third Trade Review*. Dating from December 1888, this special issue titled "The City by the Sea" promoted those golden opportunities facing Brunswick.

The unlimited possibilities for port development and international trade, resort amenities offered by the Oglethorpe Hotel and Hotel St. Simons, and the activities of a land company, the Brunswick Company, were all covered in this issue. Colorful players such as Columbia Downing, Max Ullman, W.E. Kay, Charles P. Goodyear, and Newton S. Finney partnered with an enigmatic figure, James F. O'Shaughnessy.

A creative man of vision, O'Shaughnessy's dreams and aspirations cast a wide net. Considering Brunswick's historic challenges and growth through fits and starts, a combination of investments promised a new day and a bright future for the City by the Sea. Buffeted by panics and depressions, conflicts and wars, a diverse population demonstrated a remarkable resiliency. Energized by high expectations, everyone had a share in a "new tomorrow."

Following the suggestions of professionals at Georgia Archives and the Georgia Historical Society, I opted to cite credit directly beneath the images. The division of chapters was strictly an arbitrary choice, guided as I was through a review of other books in the *Images of America* series. Although not an exhaustive bibliography on Brunswick's rich history, those books listed were both helpful and instructive. Oral traditions embellished the romance of the past.

What a challenge and adventure this worthwhile project has been for me! I hope that you approach this visual history with a great sense of expectation and enjoy the images and text as much as I did in compiling a glimpse of the City by the Sea. Ponder the magic of the coast, and the wonder of it all, the sinuous sweep of the salt sea marshes of Glynn, and our woody, arboreal assets. Contemplate the diversity of people who color our past and the present, and do pause and reflect on a history rich beyond measure.

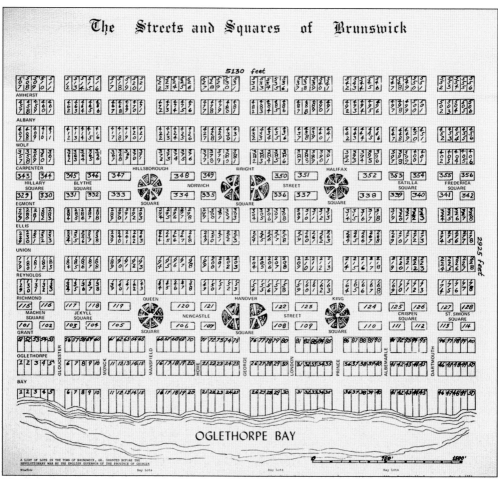

The Streets and Squares of Brunswick

Meeting in Savannah, Georgia's Provincial Council authorized, in October 1770, the layout of a new town at Carr's Old Fields on the Turtle River. Honoring King George III and the ruling House of Hanover, Brunswick reflects Anglo-Germanic heritage and was surveyed by George McIntosh of the distinguished military family. Influenced by an early-18th-century Georgia promoter, Sir Robert Montgomery and his famed "Margravate of Azilia," the new town was laid out on the "Oglethorpe Plan." Featuring a grid repeat pattern of regularly spaced squares and town lots, Oglethorpe's plan represents an innovative urban design within a heavily forested "garden" setting. (Courtesy of Coastal Georgia Historical Society [CGHS].)

# One

# EARLY DAYS

*Numerous Native American sites dot the landscape with old oyster shells and the long ago presence of late Archaic (2,000–1,000 BC) and Woodland Indians (1,000 BC–700 AD). Their contributions to the rich history of the port city have been little celebrated, unlike the colonial soldier Capt. Mark Carr. Arriving in 1738 at Frederica, Carr served in Gen. James Oglethorpe's Marine Boat Company and made his mark in the fledgling colony of Georgia. He participated in the struggle for empire between England and Spain and quickly adapted to advantageous circumstances. At an opportune time, Carr erected a military outpost on the mainland after receiving a crown grant. Georgia's Colonial Records document the hard work of one William Ruff cultivating corn and tobacco at Carr's Fields; the name "Plug Point" suggests a leafy cash crop.*

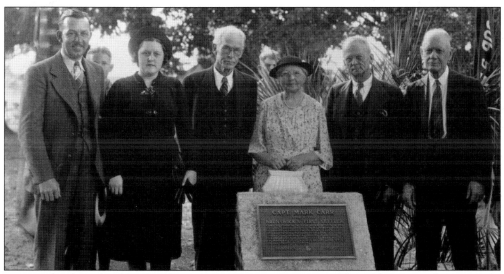

Ruins of colonial tabby buildings reminiscent of Carr's Old Fields—an early name for Brunswick's mainland peninsula—stood well into the 20th century. In 1953, the Georgia Historical Commission erected a large bronze plaque at First Avenue and Union Street recognizing Mark Carr. In addition, tabby and brick from Carr's 1760s home at nearby Blythe Island provided the foundation for a handsome plaque erected in his honor as "Brunswick's First Settler" by the Brunswick chapter, National Society of the Daughters of the American Revolution (NSDAR), Regent Mrs. C.H. Leavy. Unveiled on October 20, 1938, at Queen's Square, the plaque was accepted by Carr's great-great-grandson Robert A. Calder. (Courtesy of Margaret Davis Cate Collection #997, Fort Frederica National Monument, Georgia Historical Society.)

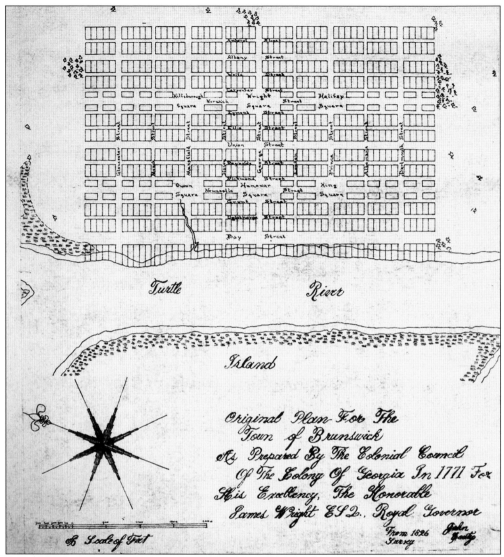

Original Plan For The Town of Brunswick As Prepared By The Colonial Council Of The Colony Of Georgia In 1771 For His Excellency, The Honorable James Wright ESD., Royal Governor

From 1826 Survey

After Georgia's esteemed Board of Trustees surrendered their charter on June 25, 1752, the proprietary colony reverted to the administration of a series of three royal governors (1754–1775) who oversaw parish affairs. An unpopular Gov. John Reynolds (1754–1757) was succeeded by a skillful politician and diplomat, Gov. Henry Ellis (1757–1760), and his successor assumed office in the fall of 1760. A professional administrator, James Wright (1760–1775) governed for 15 years and enjoyed a reputation for "Integrity and Uprightness joined with solid sense and sound Judgment." He confronted hostile sentiment over unpopular tax measures, such as the Stamp Act (1765) and the Townsend Acts (1767). Within this context, the increasingly clamorous "Liberty Boys," initially of Saint John's Parish, advocated support for the Northern colonies foreshadowing the American Revolution. Notice the prominence of Wright Square on the original 1771 plan for the Town of Brunswick, Saint David's Parish (1765–1777), and the use of names on the landscape suggesting Tory sympathies and serving as reminders of Georgia's close ties to the Mother Country. After the American Revolution, Brunswick retained English names for its streets and spacious squares. (Courtesy of CGHS.)

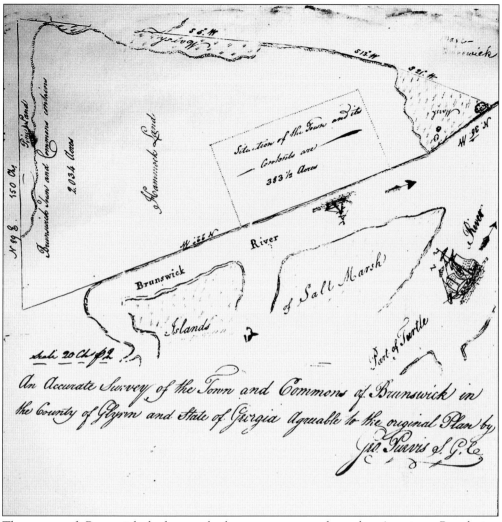

The town of Brunswick had scarcely begun to grow when the American Revolution (1776–1781) intervened, and a largely Loyalist population fled to Spanish Florida or the Caribbean basin. Less than 200 town lots had been granted. In 1788, Georgia's General Assembly appointed a number of commissioners whose duty was to survey and sell town lots for the support of an academy. Town Commons were set aside on three sides, and by 1796, commissioners were again appointed; they were George Purvis, Richard Pritchard, Moses Burnett, John Piles, and John Burnett. When the county seat was removed from Frederica to Brunswick, the General Assembly passed and approved, in February 1797, an act appointing new commissioners and empowering them to sell property located in the Town Commons. With proceeds directed toward academy support, one-half of the funds was allotted for the erection of a courthouse and jail. Seven tracts, including the Wilson tract (Windsor Park), Urbana, and the Clubb tract (Dixville), were among those sold for community needs. Notice on surveyor George Purvis's map the rectangular shape of a 383$\frac{1}{2}$-acre "Old Town." (Courtesy of CGHS.)

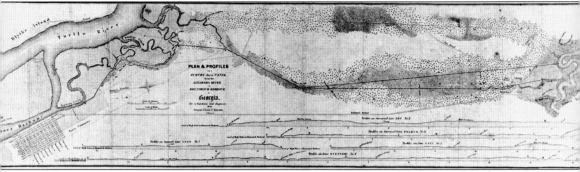

Local planter Thomas Butler King, his brother Stephen Clay King, and William Wigg Hazzard, who wrote an early history of St. Simons Island, received a new charter for the Brunswick Canal and Railroad Company in 1834. No survey had previously been done of the canal route, and T. Butler King assumed the expense of hiring a noted civil engineer. Graduated from Harvard in 1800 and today known as the "Father of Civil Engineering in America," Loammi Baldwin Jr. was notable for his work in the 1820s on the Union Canal from Reading to Middletown in Pennsylvania. His name not only lent prestige to the project but provided concrete plans, which you can see in this image, and a report. "Flush times in Brunswick" ensued with construction on the canal, the chartering of the Bank of Brunswick, and in 1835, the Georgia legislature's charter of the Brunswick and Florida Railroad Company. Attractive incentives lured Northern investors, and the period literature speaks of the "natural advantages" of Brunswick. (Courtesy of Margaret Davis Cate Collection #997, Fort Frederica National Monument, Georgia Historical Society.)

Born at the legendary Indian town of Coleraine on the lazing St. Mary's River, Urbanus Dart Sr. (1800–1883) settled in the village of Brunswick as a young man filled with ambition and with an eye for opportunity. Dart and William B. Davis received headright grants for large tracts of land, and in 1826, a group of investors, including Davis and Dart, obtained a charter for the construction of a canal. After a lapse of interest, the charter was re-granted as the Brunswick Canal Company. Davis and his business associates were aided by state appropriations in a headlong attempt to rival the port of Savannah, siphoning traffic and products from Georgia's interior via the Altamaha River and by canal to the port of Brunswick. Later, this effort was abandoned and taken up by a local planter and group of Northern investors. Many Dart relatives live along the coast today and proudly recall how their ancestor donated land for the construction of historic local churches, such as the First Presbyterian Church and the First United Methodist Church. Their family patriarch served his community as mayor of Brunswick (1841–1843) and in the Georgia legislature on two occasions, 1838–1840 and 1865–1866. (Courtesy of Sara B. Ratcliffe and Bill Brown.)

An enchanting image of the ill-fated Brunswick-Altamaha Canal was reproduced as a postcard by a 20th-century local printing house, Glover Brothers and the Albertype Company. The wide canal was dug by slaves and Irishmen from Boston and was completed in June 1854. Its beginnings on the South Altamaha River assured labor provided by people of African descent from the nearby delta rice plantations. The old canal ends at Academy Creek, which drains into the Brunswick River, and travelers can view a portion of the 12-mile long historic canal when passing over the route known as "Canal Road." (Courtesy of E. Ralph Bufkin.)

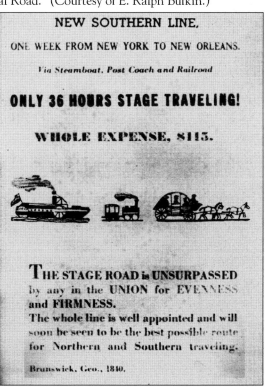

Northern investors ventured risk capital to realize the visions of enterprising promoters, but none were prepared for the Panic of 1837. Land speculation, transportation routes via canal, riverine transport, and prospects of a railroad had fueled a booming economy in Brunswick. In the billing image printed at Brunswick, 1840 travel from north-south routes was encouraged in a graphic way on the "New Southern Line." (Courtesy Margaret Davis Cate Collection #997, Fort Frederica National Monument, Georgia Historical Society.)

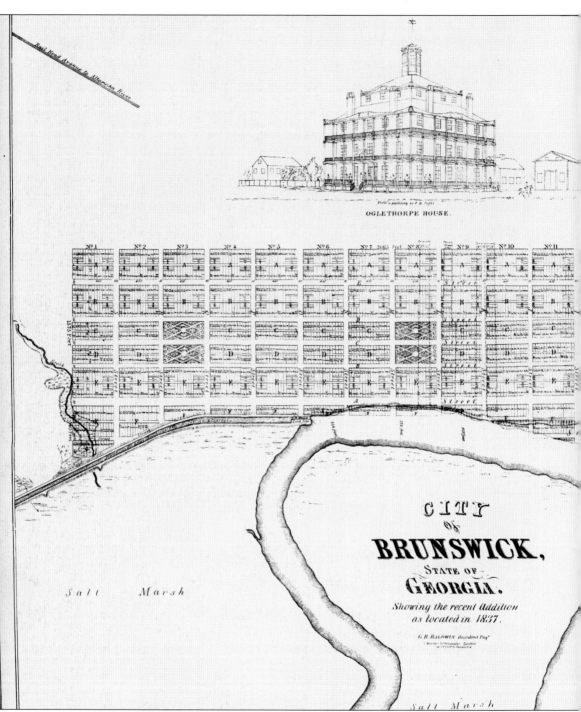

OGLETHORPE HOUSE.

CITY OF BRUNSWICK, STATE OF GEORGIA.

Showing the recent Addition
as located in 1837.

G. R. BALDWIN Resident Eng.

Excavation of the ill-fated canal yielded ancient fossil bones—Megatherium, Mastodon, Mammoth, Hippopotamus, Horse, Ox, and Hog—studied by local planter extraordinaire James Hamilton Couper and sent in 1842 to the Philadelphia Academy of Sciences. While naturalists enthused over the unusual association of extinct mammals, land speculation fueled the dreams of Thomas Butler King and Boston investors. In the detailed 1837 map of Brunswick, notice the

14

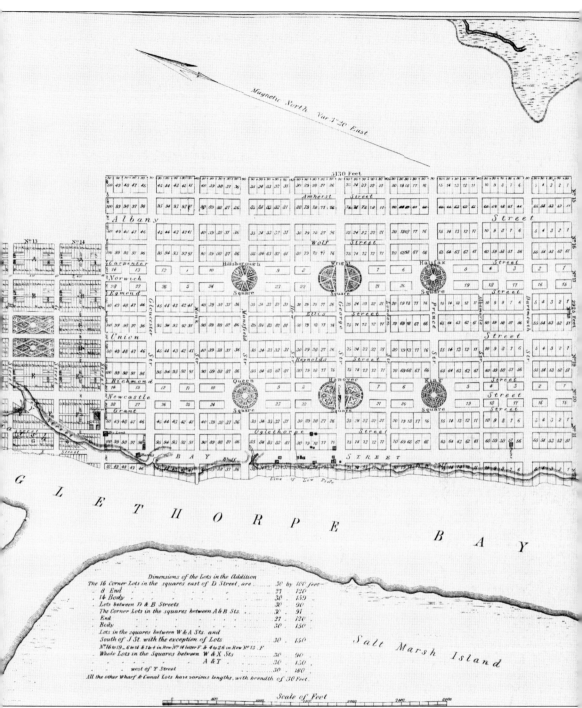

"New Town" through whose sale developers envisioned underwriting costs for the canal and the provision of lots for those new residents flocking to the city. Located north of F Street and west of Wolfe Street, and covering 64 city blocks and two public squares, New Town was patterned after the Oglethorpe Plan and extended from the Old Town. (Courtesy of Georgia Historical Society, GCCL #144.)

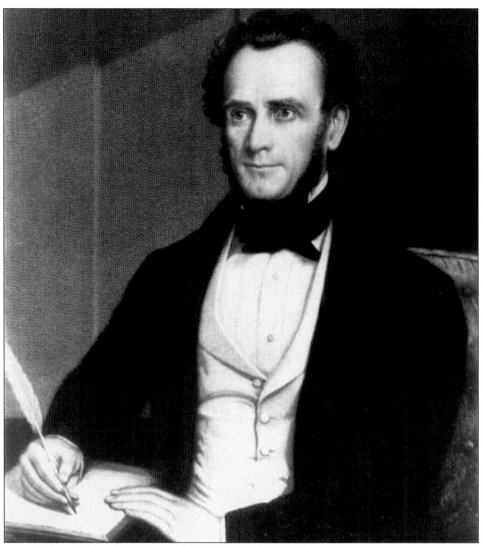

Born in Palmer, Massachusetts, to a family with old New England ties and patriot service in the American Revolution, Thomas Butler King (1800–1864) was led to coastal Georgia and beyond on the political scene. He read the law under prominent attorney and jurist Judge Garrick Mallery in Wilkes-Barre, Pennsylvania, preparing him to serve, initially, as a Whig politician. On both a state and national level, King contributed through multiple terms of office. As a young man, he followed his brother Stephen Clay King's lead by moving to south Georgia and marrying into an established, wealthy planter family. When in his mid-20s he married Anna Matilda Page, only daughter of William Page, King acquired claim to Retreat Plantation on St. Simons Island. Joining the ranks of the coastal "nabobs," Thomas Butler King profited from his wife's wealth and training to assume responsibility for plantation management and the value of their cash crop, "sea island" or long staple cotton. Extensive landholdings and the business acumen of his plantation mistress empowered King to travel widely in service to Georgia and his country. Looking outside of his island boundaries, King's role as a businessman and promoter of the port of Brunswick—a bank, railroad, and the Brunswick-Altamaha Canal—proved a visionary highwater mark. (Courtesy of ISH Aiken Jr. and CG&P, Inc./Weekend.)

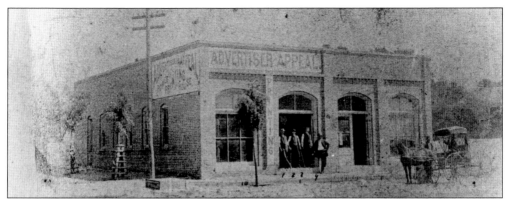

In the 1830s Brunswick's first newspaper, the *Brunswick Advocate*, appeared in response to an encouraging economic climate and projected growth in population. Local and state leaders had advocated Brunswick as a suitable site for a naval depot and for exploiting the abundant, native live oak. In January 1857, the 36th Congress authorized purchase of 1,100 acres at Blythe Island. Within just a few years, the coast was blockaded and the Brunswick Riflemen, CSA went off to war. With the defeat of the American South, the hard times of the Reconstruction period descended upon Dixie but brought renewed interest in the port of Brunswick. On March 24, 1875, the *Brunswick Advertiser* first appeared through the work of a Liberty Countian T.G. Stacy, editor and proprietor. In 1881 Stacy purchased the weekly paper the *Seaport Appeal*, previously owned by Carey W. Styles, and combined the names. The *Advertiser and Appeal* hit the press on February 19, 1881. (Courtesy of CGHS.)

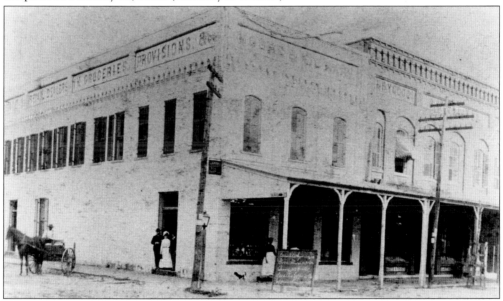

As far back as the colonial period, skilled tradesmen such as George Spencer and John Roberson of Frederica, with their four indentured servants, had labored over making brick from local clay deposits. On St. Simons Island, older maps note the presence of a winding "Brick Kiln Creek" near Hawkins' Island. In general, the sandy loam of local soils proved unsuitable for brick making. In the fragile image shown, an unidentified person noted the "First Brick Building" built in Brunswick as Moore and McCrary's Grocery Store, and a business operated by W.A. O'Quinn & Son. Located on the corner of Gloucester and Newcastle Streets, the old building serves as a reminder of Brunswick's early days. (Courtesy of CGHS.)

In Georgia's piney woods interior, virgin stands of the coveted long leaf yellow pine and the ancient cypress trees of the coastal swamps offered an ideal opportunity for men with an entreprenurial spirit. These and other abundant natural resources brought a new cast of colorful characters to the Georgia coast, the advent of a sawmilling era (1874–1903), timber rafting down the Satilla and Great Altamaha Rivers, the growth of mill villages, and the development of the port of Brunswick. As early as 1866, affordable waterfront property, cheap labor and a willingness to work, and rail transport beckoned to men such as the Cook Brothers, John and Samuel of Worcester, Massachusetts. They contributed to the economy of their new community and served in leadership roles. In fact, their mill regulated the time of the town when Brunswickians set their clocks and timepieces by the Cook's Seth Thomas Regulator Clock (c. 1850–1860). Cook Brothers blew their whistle by the clock! (Courtesy of Mrs. George H. Cook Jr. and Fred Cook.)

In an undated photograph, a group of citizens gathered at the entrance to a large, frame Masonic Temple. Through oral traditions and the work of Frederica Academy students in their "Foxfire"-style serial publication of oral history interviews, *Ebbtide*, we glean information about the building's usefulness. In an interview, Mrs. Fernando Torras remarked about early days in the City by the Sea. "Hanover Park was the center of Brunswick's civic, cultural, and social life," she said. Mrs. Torras estimated the General Assembly allocated $12,000 raised through lottery proceeds for building the seat of government, which also served as a jail, in the center of Hanover Park. "The social meetings were held there and the government had its meetings there in the Masonic Temple." (Courtesy of Sara B. Ratcliffe and Bill Brown.)

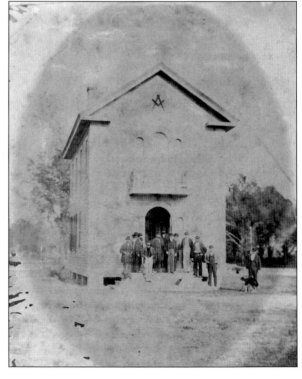

# Two

# On the Brunswick Waterfront

*The term "natural advantage" appears consistently and repeatedly in period literature promoting the City by the Sea. Even today, after almost 250 years of settlement, the dreams and aspirations of Brunswickians, business men and women, hinge on the growth and development of the port of Brunswick and the completion of a golden "bridge to the future." Consider the burly little harbor tug shown in these images, a working class vessel whose maneuvering requires consummate skill. Capturing the essence of a watery environment and serving as a cornerstone for the maritime world, the tale of the little tug serves as a reminder of perseverance, a virtue possessed by many within the City by the Sea.*

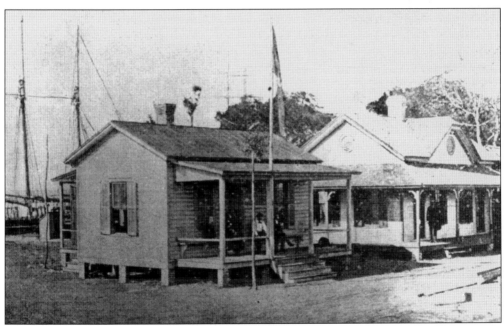

Tall-masted sailing vessels in the background of this image on the Brunswick waterfront suggest prosperity belied by the simplicity of a functional structure. A small beckoning porch offers shelter from inclement weather, as well as a venue for observing both waterfront and street activities. Headquarters for a seafaring man, Rosendo Torras's consulate office served North Atlantic, Mediterranean, Caribbean, and South American port trade—Spain, Cuba, England, Portugal, Argentina, Paraguay, Sweden, and Norway. (Courtesy of Richard and Gini Steele.)

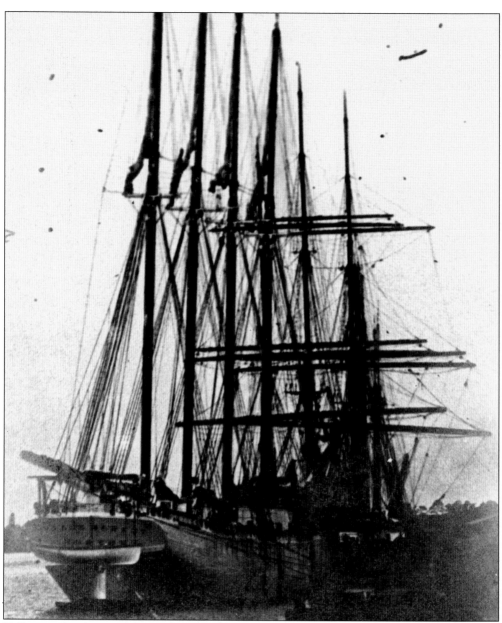

Tall-masted sailing vessels along Brunswick's waterfront await the loading of the bounty from Georgia's interior forests or manufactured products, such as naval stores. By 1898, a native of Arenys de Mar, Spain, Rosendo Torras instigated the large-scale export of lumber to foreign destinies, and the "golden era of sailing vessels" had begun in the City by the Sea. Within just a few years—compared with other south Atlantic ports—Brunswick ranked first in export of lumber, second in naval stores, third in cotton, and fifth in phosphates. In the midst of an era of unprecedented prosperity, the city had weathered the storm of a devastating 1893 yellow fever epidemic, a worldwide depression, and the slings and arrows of outrageous fortune with a resiliency of remarkable degree. Sailors from foreign countries scurried on the waterfront, and their "sea fever" characterized a period when Brunswick was coming into mainstream America. (Courtesy of C.S. Tait Sr. Photograph Collection and C.S. Tait Jr.)

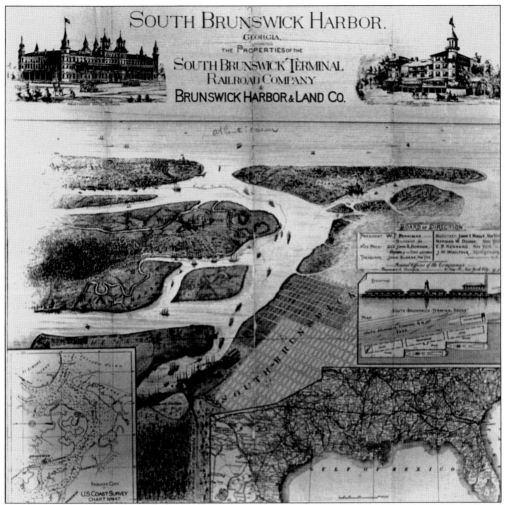

A great Victorian-era promotional piece appeared in a December 1888 issue of *Harper's Magazine Advertiser*. The article was titled "Brunswick-By-The-Sea" and the author extolled the healthful virtues of the cooling salt sea breezes and the piney woods fragrance. "When the two are combined, as they are at Brunswick, there could be nothing more beneficial to persons in all conditions of health." Northern industrialists had acquired Jekyll Island, and a villa colony in Windsor Park was predicted as a winter resort. "Brunswick by the Sea is destined to be the winter Newport of America," the author opined. Within this context, a neglected figure, inventor, entrepreneur, and long-term member of the exclusive Jekyll Island Club, James F. O'Shaughnessy (1841–1914) dated his interests in the City by the Sea. He initially visited in April 1887 and within eight months formed a land company, which owned vast tracts of real estate and resort hotels. The Brunswick Company purchased 1,864 city lots and held controlling interest in both the Oglethorpe Hotel and the St. Simons Land and Improvement Company, as well as the Brunswick Street Railroad Company. The corporation purchased 9,000 feet of deep waterfront wharfage on Back River, 16,000 feet on both sides of the East Tennessee, Virginia and Georgia Railroad docks, and Long Island (Sea Island). (Courtesy of Margaret Davis Cate Collection #997, Fort Frederica National Monument, Georgia Historical Society.)

Prepared by the Savannah District office U.S. Corps of Engineers to accompany an annual report, the Brunswick Harbor Map of 1892 shows the wharfs in the halcyon days. Colonel Charles P. Goodyear Sr. (1842–1919) was convinced of Brunswick's destiny as a great south Atlantic port. He took time away from a successful law practice and labored tirelessly for harbor deepening through the use of dynamite to open the port of Brunswick to deep draft vessels and international trade. Period city council minutes document Goodyear's efforts. Raw materials awaited export, including resinous long-leaf yellow pine, short-leaf pine and loblolly, oak and cypress, and other woods cut out of a rich Georgia interior. Timber and marketable wood supplies considered growing in "almost exhaustless quantities" were available by rail and river transport. (Courtesy of Stephen King Hart.)

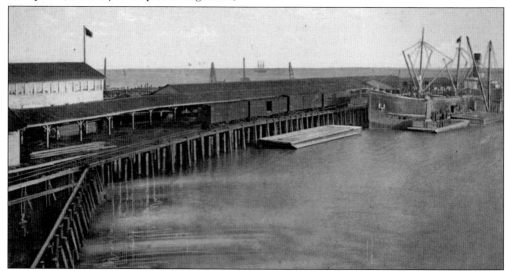

A postcard depicts the old ABC Terminal and the steamer *Ossabaw* of the Brunswick Steamship Company unloading freight. Affiliated with the Atlanta, Birmingham and Atlantic Railroad Company, the two concerns purchased 2,600 waterfront feet encompassing 140 acres of highland and salt marsh, and dredged the channel to 28 feet. Coastwise and foreign commerce served markets from New York to Brunswick and Brunswick to Havana. Creating a model for sophisticated terminal construction, its designers staged the port of Brunswick for development and to realize the "eldorado of American enterprise." (Courtesy of Jane Hildebrand.)

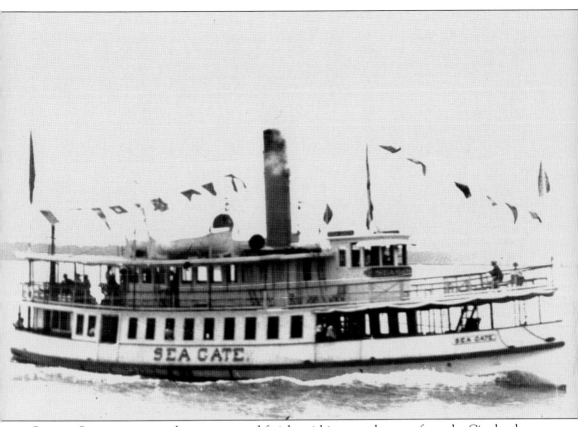

Steamer *Seagate* transported passengers and freight within coastal waters from the City by the Sea to a remote, seasonal family vacation land on St. Simons Island. Other steamers, such as the *Emmeline* and the *Hessie*, plied the waterways, providing transport. All three vessels were memorialized through resort-era businesses, such as a popular, now defunct restaurant, The Emmeline and Hessie Restaurant, once located on the Frederica River near the entrance to St. Simons Island at Gascoigne Bluff. Built by the Niall family, a modern 1950s-era "Sailfish Motel" was renamed "The Seagate Inn" by its current owners. (Courtesy of C.S. Tait Sr. Photograph Collection and C.S. Tait Jr.)

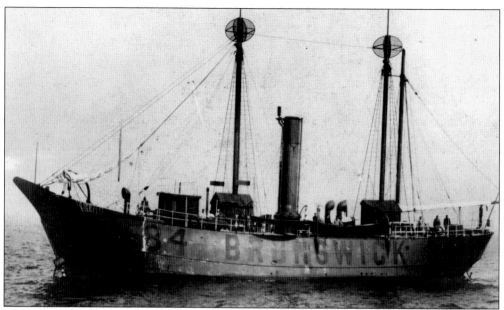

Numerous vessels—such as the ship *Brunswick* presented by the City of Brunswick to Atlanta for the 1887 Piedmont Exposition—and an airplane have honored the port city's name. In this rare image is the Brunswick *Lightship*. Serving the needs of the U.S. Lighthouse Service, the vessel was useful for directing ships into the shipping channel and served with the U.S. Navy, 1918–1919. (Courtesy of E. Ralph Bufkin.)

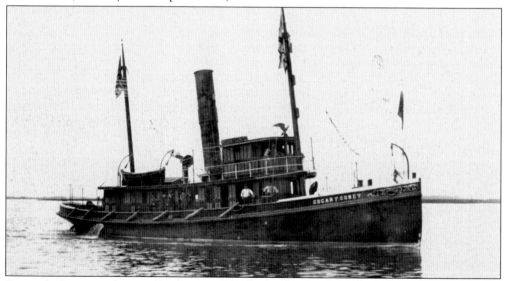

Doing the business of towing for the port of Brunswick, the *Edgar F. Coney* carried the name of the president of the South Atlantic Towing Company, Edgar Fairchild Coney Sr. (1857–1915). E.F. "Ted" Coney Jr. (1891–1932) followed in his father's footsteps and was engaged in the lumber business when logs were rafted from Georgia's interior to Darien, Brunswick, and Satilla River settlements where sawmills whirred. Considered an extremely fast tug, the *E.F. Coney* performed equally in the waters of Oglethorpe Bay and in long-distance towing; the vessel was closely associated with "Commodore" of the fleet, Capt. Leo Lomm, seen in another image. (Courtesy of C.S. Tait Sr. Photograph Collection and C.S. Tait Jr.)

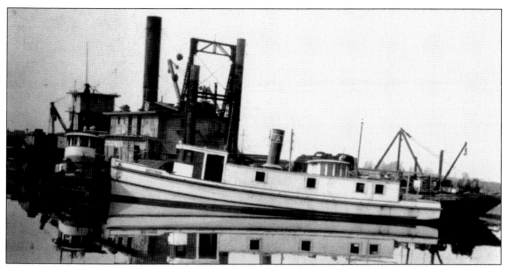

The 65-foot vessel the *Big Crop* was built near Norfolk, Virginia, for a fertilizer company. It featured a cypress hull and pine cabin. When sold at auction and brought down to Charleston, South Carolina, in August 1942, marine mechanics dropped its engine and installed a powerful Caterpillar diesel engine. The *Big Crop* supported the war effort by weaving submarine nets near jetties in coastal waters. After its purchase by the Brunswick Towing Company, it worked coastal waters hauling loaded pulpwood barges, constructing a winding Jekyll Island Causeway and the Lanier Bridge. (Courtesy of Lois F. Ross and Capt. Leo Ross.)

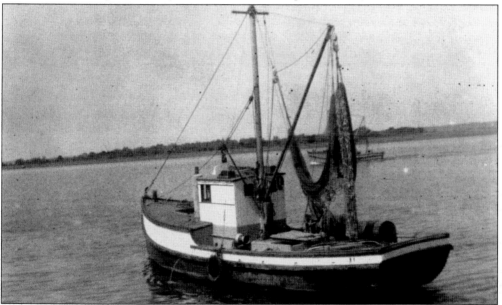

After World War II, three friends, Leo Ross, John Henry (J.H.) Browning Jr., and Harley Glover, created the Brunswick Towing Company. Although through time ownership changed, the business operated within Glynn's coastal waters between 1946 and 1976, and vessels owned by the company worked on the construction of the Sidney Lanier Bridge and in building the Jekyll Island Causeway. Sometime between 1953 and 1961, the Brunswick Towing Company bought from Howard McDowell the 40-foot vessel, featuring a Chrysler Crown engine, seen in this image—the *Captain Benson*. (Courtesy of Lois F. Ross and Capt. Leo Ross.)

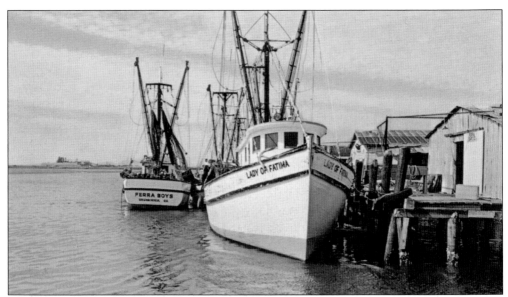

Glimpse a few wooden shrimp trawlers of the Portuguese Fleet, reminiscent of yesteryear on Brunswick's waterfront. The postcard reads "One of the busiest Harbors on the East Coast, is alive with activities and a City of Opportunity for Industry and Workers." Naming her the *Lady of Fatima* likely beseeched blessings for the vessel, and the shrimp fishermen of the *Ferra Boys* worked for a prominent Portuguese family. When coming to America, they carried with them their vast wealth of knowledge from their Mediterranean Old World home. (Courtesy Georgia Historical Society.)

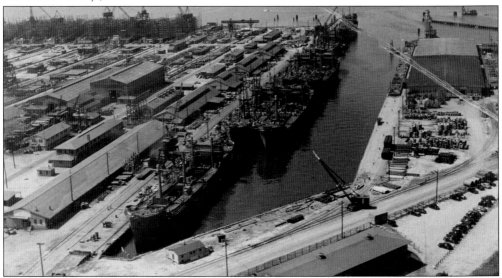

A deep basin for docking unknown Liberty Ships looms prominent in this image taken at Oglethorpe Bay, where a beehive of daily activity occurred. After leaving their rural homes, brave and stalwart, strong young men and women labored here in support of the World War II effort. The Brunswick Shipyard was supervised by experts, such as Emil Kratt who took the output of the J.A. Jones Construction Company to unprecedented levels in December 1944. What a win-win circumstance these patriotic days bestowed upon the port of Brunswick and especially the men and women who made it happen! (Courtesy of Charles E. Ragland.)

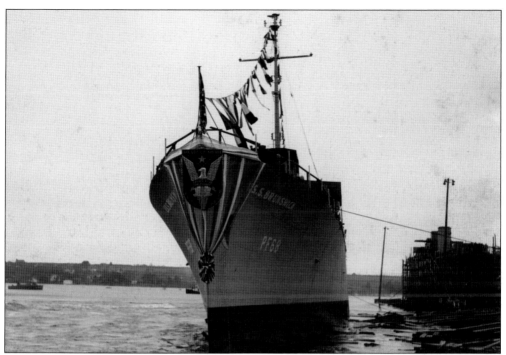

Emblazoned on the bow of the vessel USS *Brunswick* is an eagle medallion banner proclaiming an "Award of Merit Maritime Commission." "Ships for Victory" was a term by which the Liberty Ships were commonly known. Launched on November 6, 1943, into the Oglethorpe Bay at the Brunswick shipyard by J.A. Jones Construction Company, patrol frigate PF68 weighed between 5,000 and 7,000 tons and guarded coastal waters during World War II. (Courtesy of Charles E. Ragland and Ruby Berrie Collection, Bryan-Lang Historical Library.)

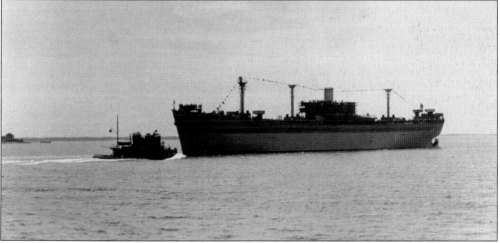

Catch a portside view of a 1940s Liberty Ship in the waters seaward of where the Sidney Lanier Bridge was built in the mid-1950s. In the left background glimpse the old dockage of the U.S. National Quarantine Station, which in the 1940s had been recently de-commissioned and gone into private ownership. In a more prosperous era, quarantine facilitated growth and development in the port of Brunswick and made possible a lucrative international trade. (Courtesy Charles E. Ragland and Ruby Berrie Collection, Bryan-Lang Historical Library.)

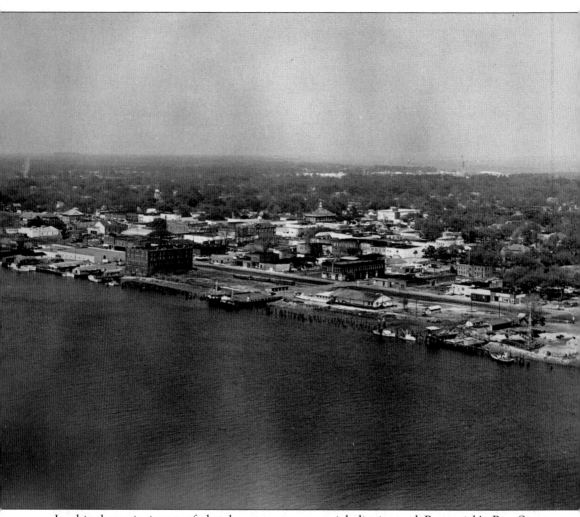

In this dramatic image of the downtown commercial district and Brunswick's Bay Street waterfront, a number of structures remain familiar—gone but not forgotten—such as the Downing Building. Notice the Custom House, undergoing restoration at the millennium's dawn as the "new" city hall. Shrimp trawlers line a watery setting where dedication of the Brunswick State Docks had not yet occurred. A shore luncheon setting welcomed Gov. S. Ernest Vandiver (1959–1963), who, on August 25, 1960, accepted the dockage on behalf of the state of Georgia. The master of ceremonies for the occasion was Hon. Charles L. Gowen, Glynn County state representative. The chairman of the Glynn County Commission, Col. James D. Gould, and Mayor Millard Copeland welcomed the assembled guests. Hon. Robert C. Norman, chairman of the Georgia Ports Authority, presented the docks to the state of Georgia, foreshadowing a new day in the port of Brunswick. Demonstrating "outstanding foresight and leadership ability" in 1962, Governor Vandiver acquired Colonel's Island for the Georgia Ports Authority. In June 1990 the Vandivers attended the unveiling of a plaque near the guard house at Colonel's Island, recognizing the governor's contributions and island as a "vital element in the economic progress and well-being of the state of Georgia." (Courtesy of James D. Gould III.)

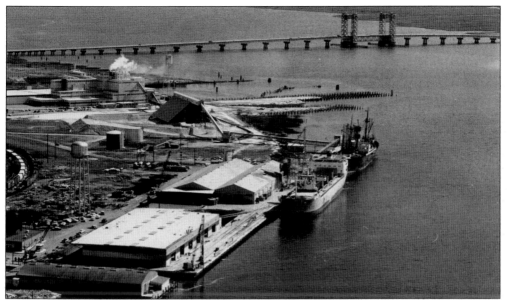

Brunswick waterfront businesses and the 1950s low-level, vertical-lift Sidney Lanier Bridge create a backdrop and curious view of the South Brunswick River. Notice the vessels docked, and the old pilings so typical of a coastal scene where nature's unforgiving salty climate erodes manmade intrusions. The bridge has proven a landmark and anchored a major route through Brunswick and in the memories of passersby for generations. (Courtesy of Charles E. Ragland.)

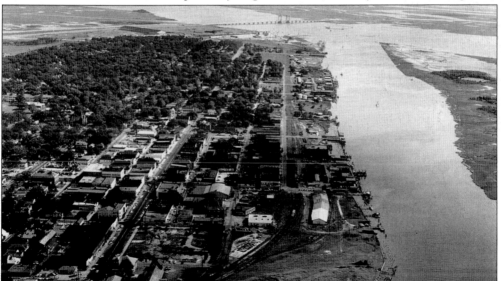

What a dramatic sweep photographer Gil Tharp captured with this image of the port! Notice a marshy Buzzard's Roost (Andrew's) Island to far right, and how a clustering of businesses line Newcastle Street within a heavily vegetated cityscape. Find a prominent Hanover Park, and a gaping vacant block where once the grand Oglethorpe Hotel reigned over the north end of Newcastle. Old pilings, shrimp trawlers, and packing houses line the waterfront on which the Downing Building stands prominent. In the distance, a dredge is at work near the Lanier Bridge. Beyond that is a beloved landmark, the old Quarantine Station at far left. (Courtesy of Gil Tharp and Phyllis S. Tollison.)

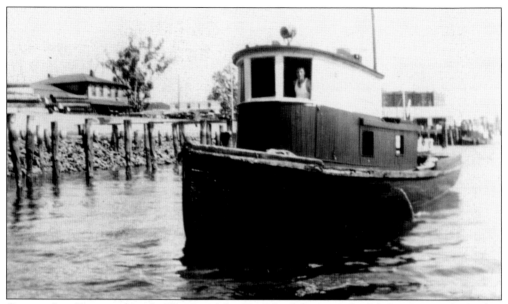

Captain Leo Ross, in the wheelhouse of the *Egg Island*, brings a derrick barge into the harbor for dockage. This typical scene serves as a reminder of a waterfront facing great change. As locals know, the Ross family's connection to the sea is a longstanding one—with Andrew Ross's affiliation with Strachan Shipping Lines and, beyond his generation, the maritime work of Captain Leo Lomm with the South Atlantic Towing Company. Consider the fast tugs *Edgar F. Coney* or the *Dauntless* and vital work in support of the port of Brunswick. (Courtesy of Lois F. Ross and Captain Leo Ross.)

Early in their marriage, Lois Ferrell Ross often worked with her husband, Leo, and enjoyed her fair share of adventure. The Rosses recalled a harrowing experience in Albemarle Sound, reminiscent of a "perfect storm." It temporarily caused marital dischord and chilled them when they encountered an unforgiving body of water and an unforgettable challenge! Ross had been hired by Capt. Frank Fernandes to bring down a government surplus vessel—the *Transco*—from Little River, Virginia, to Brunswick. Seen in other images, Captain Frank and the *Transco* plied the waters of Oglethorpe Bay for many years. In these images, Lois and Capt. Leo Ross are seen in the wheel house of the *Big Crop*. (Courtesy of Lois F. Ross and Capt. Leo Ross.)

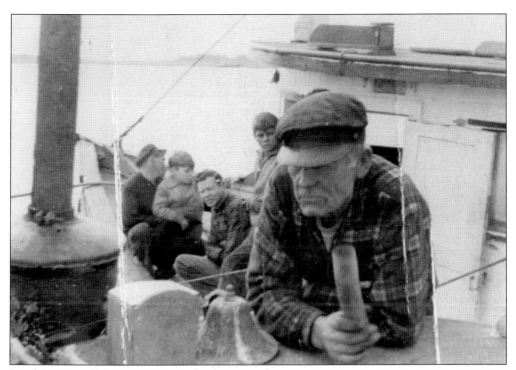

Frank McDowell (1896–1979), in the foreground, is pictured with, from left to right, Shelton and Ben McDowell, Johnny Jones, and David McDowell. Born and reared on Jekyll Island where his father worked as a caretaker for the Rockefeller family, Frank McDowell benefited from the education offered by the Jekyll Island Club and led a hard life in support of 16 children and his wife. Shrimp trawlers with which McDowell was associated boasted names such as *The Mildred*, *Bullfrog*, *Leaping Lena*, and the *Clara L*. His children worked alongside him, learning maritime skills. Daughters Betty and Lana pursued non-traditional roles as female "strikers," or crew members who haul in the nets and whose job requires agility, hardiness, and foresight for survival. (Courtesy of Lana L. Taylor and the McDowell family.)

Remembered as "an all-around man who could do most anything," Capt. James Edwin "Ed" Royall Jr. (1896–1981) operated the South Atlantic Marine Company in the 1930s at the foot of Albemarle. His marine shop was built on pilings and a dockage extending 130 feet into the river, with a nearby marine lift for hauling out vessels up to 100 feet long. Two of Royall's expert helpers were machinist Willie Cooper and a highly skilled ship's carpenter, Oswald Curet. (Courtesy of Lois F. Ross and Capt. Leo Ross.)

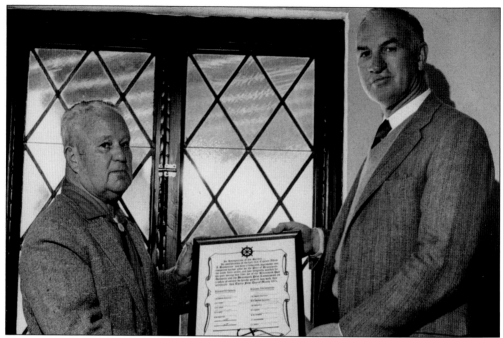

Capt. Alfred A. Brockinton was feted to a retirement luncheon on March 31, 1971, at the King and Prince Hotel. The event was co-sponsored by the old Brunswick Port Authority and the city Pilot Commission, honoring his 40 years of service (1931–1971) as Master Pilot to the Port of Brunswick. Captain Brockinton (left) was heaped with accolades and received a plaque from Bill Brown, secretary of the Pilot Commission. (Courtesy of Lou Nell B. Gibson and Nancy B. Pittman.)

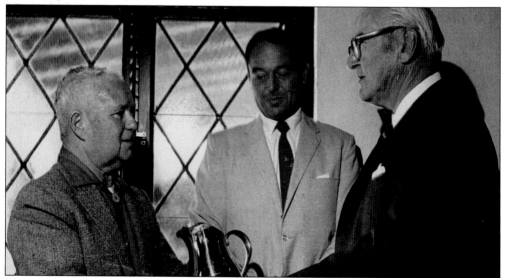

From left to right, Capt. Alfred A. Brockinton (1906–1973) receives a handsome silver pitcher from harbor pilot Edwin Fendig Jr. and local banker and chairman of the Brunswick Port Authority I.M. Aiken. The beloved long-term Master Pilot accepted this gift in recognition of his retirement and "faithful and efficient service to the Port of Brunswick, Georgia." (Courtesy of Lou Nell B. Gibson and Nancy B. Pittman.)

# *Three*

# Corridors, Landmarks, Historic Structures

*Corridors direct movement and define day-by-day routes along which one can view familiar scenes, landmarks, and historic structures. When the old landmarks no longer show the way, the imagery remains—enhancing our sense of well being and a peculiarly Southern "sense of place." Defining our past, markers and monuments dot the landscape as reminders. They enrich our sense of history, and provide instruction for future generations. Listed on the national register on April 3, 1979, the "Old Town Historic District" encompasses Brunswick's original layout where today citizens actively pursue restoration of old homes and buildings, which were constructed of materials of lasting substance. Their hard work preserves a flavor of the historic past.*

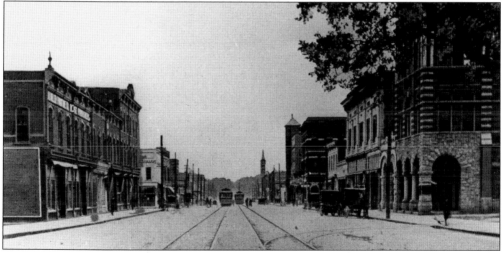

Looking south down a Newcastle "main street" corridor, notice the substantial character of downtown buildings in turn-of-the-century Brunswick. Dating from 1911 to 1912, an electric street railway line serviced city residents from the south end at Dartmouth and Union, north to "G," and east to another northbound corridor at Norwich Street. Headquartered at 1525 Grant Street, ownership of the City and Suburban Railway Company included President F.D.M. Strachan of Strachan Shipping Company, and other officers were Albert Fendig, Frank D. Aiken, and George Smith. By the 1930s, this public transportation provider no longer appeared in city directories. Notice how the clock from the city hall dominates the skyline and the building anchors the south end of Newcastle. (Courtesy of Richard and Gini Steele.)

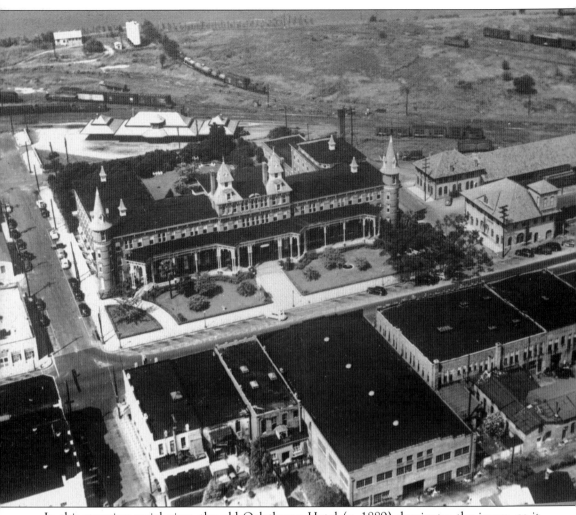

In this stunning aerial view, the old Oglethorpe Hotel (*c.* 1889) dominates the image, as it anchored the north end of Newcastle, the city's "main street." Myth held that the Oglethorpe was designed by the ill-fated architect Stanford White, but fact is the elusive New Yorker J.A. Wood produced the plans. In the background, notice the switch yard for trains and the Southern Railroad passenger terminal; to the far right once stood the ACL Freight Depot. Prior to its demolition, cultural icon Mary McGarvey mused over saving it from the wrecking ball and converting it to a charming "Fanny Kemble Coffee Shop." In the foreground, notice "F" Street bisecting the Newcastle corridor, and the rooftops of the old Lafayette Grill, Brunswick News, Gould Ford Motor Company, and the Royal Hotel. Consider "The City By The Sea," in the *Third Trade Review* special issue of the *Advertiser-Appeal*, printed in 1888, admonishing "If you want to invest money, we believe you will find Brunswick a profitable point." (Courtesy of Charles E. Ragland.)

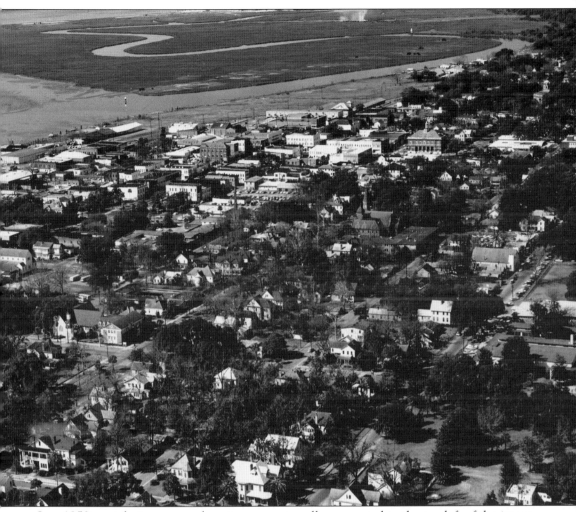

In a 1950s aerial view, a core downtown area is well represented in the top left of the image. The Old Custom House is clearly seen, and two north-south corridors predominate, Union and Egmont. Look for the following Union Street residences, churches, and public buildings: 1000 Union, First Presbyterian Church, First Baptist Church, Ludowici roof tiles of the Lissner House, the Custom House/new city hall, and Glynn County Courthouse (top right). On Egmont's northbound corridor, look for the L.T. McKinnon House, Shiloh Church, and the edges of the Glynn Academy Campus and Old Prep High, an Eichberg design. Notice the heavily vegetated cityscape, creating a sense of living in a garden. The numerous monuments dotting the landscape enhance a "sense of place" in the City by the Sea. (Courtesy of Charles E. Ragland.)

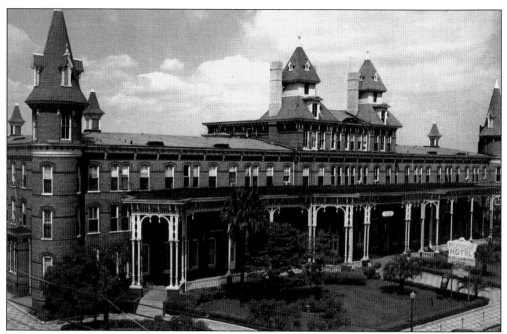

Built of Chattahoochee River hard brick, the Oglethorpe Hotel was flanked by turrets and a wide veranda, 240 feet in length, beckoning guests to the grand parlor. Crystal chandeliers, polished floors, and a painting, *The Battle of Flanders*, once greeted those who entered her doors. Native yellow pine complemented furnishings by the Robert Mitchell Furniture Company of Cincinnati. Carpeting, curtains, and draperies were done by M. Rich and Brothers of Atlanta. (Courtesy of Richard and Gini Steele.)

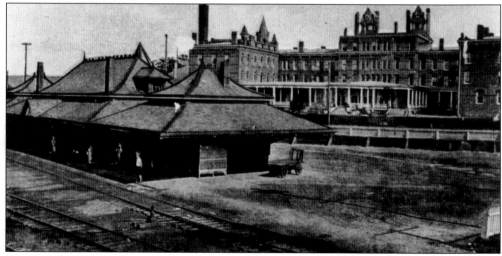

The Oglethorpe's season ran from its opening in January to a May closure, and the original St. Simons Hotel served as respite for leisure class vacationers from the summer of 1888 until its destruction by fire in December 1898. It was rebuilt as the New Hotel. A 1914 image shows just how convenient travel was by train—Jekyll Island Club members disembarked and quietly entered a rear entrance of the Oglethorpe, en route to their insular watery destination. In an unthinkable act, this grand Oglethorpe Hotel was demolished in 1958 and was immortalized through the art of Stella Morton. (Courtesy of CGHS.)

In January 1889 Mayor D.T. Dunn presided over a regular meeting of the Brunswick City Council where J.M. Madden submitted a committee opinion. Brunswick was not the little town it once was but a thriving, growing city, and from this beginning evolved the construction of "Old" City Hall. Sealed proposals dating from December 1889 authorized architect Alfred S. Eichberg (seen on page 58) to draw up plans, and the contract was awarded to Anderson and Sharp. Built at a cost of $33,000 in the Richardsonian-Romanesque style, Old City Hall is the second oldest standing public building in Glynn County. It represents aspirations of enduring stability and community achievement in a period of unprecedented growth and prosperity in the City by the Sea. Presently, the structure is undergoing a multimillion-dollar restoration supervised by John A. Tuten and Douglas A. Neal, architects. (Courtesy of C.S. Tait Sr. Photograph Collection and C.S. Tait Jr.)

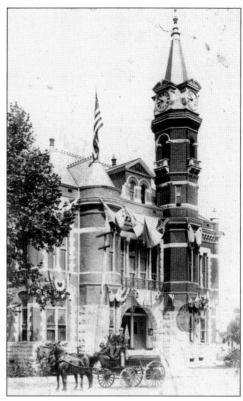

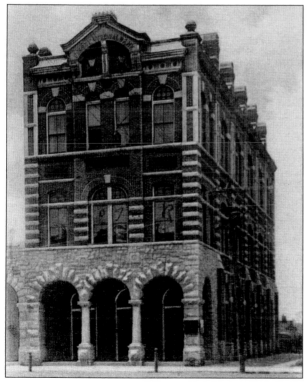

Another example of Eichberg's design, the National Bank of Brunswick demonstrates bold arcaded galleries and blocklike massing. Numbered among its depositors were local large business concerns, reflected in the officers and board of directors. Maj. Columbia Downing served as president, and assisting him were vice-presidents E.H. Mason and Albert Fendig. Directors were attorney Joseph W. Bennet, E.F. Coney of Coney and Parker, J.R. Wright of Wright and Gowen, L.R. Akins of Akins and Brothers, and New York banker Henry P. Talmadge. (Courtesy of CGHS.)

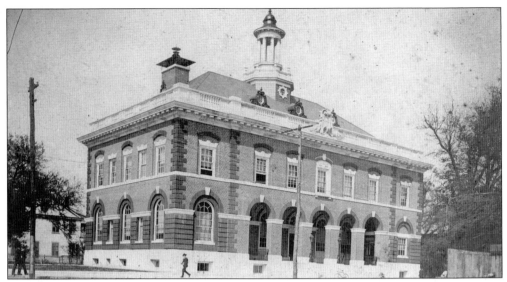

An estimated $150,000 was spent for the construction of a Custom House and post office building, by Bowen and Thomas, contractors. This handsome Georgian Revival structure (c. 1901) was the source of a court injunction brought by the McGarvey sisters and other Brunswickians who were early supporters of historic preservation and who bitterly fought its demolition. After a 1964 remodeling, the facility served as the "New" City Hall, and has been vacated only recently for restoration needs. (Courtesy of Richard and Gini Steele.)

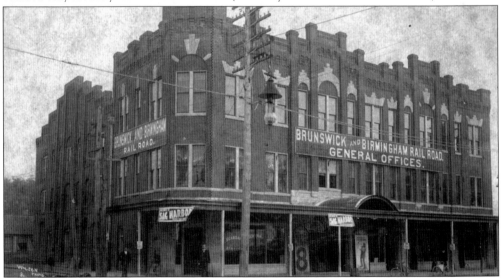

An energetic and progressive contractor, J. George Conzelman of St. Louis, Missouri, built the Grand Opera House (c. 1898) for live stage performances; it served as the general office of the Brunswick and Birmingham Railroad. Located in the heart of downtown and on a major transportation corridor, the building stands today at 1530 Gloucester. During the 1930s, the facility was converted into a movie theatre, the "Ritz Theatre." Closed in December 1976, the property was purchased by the city in 1981. Since 1990, the Ritz has been the headquarters for the Golden Isles Arts and Humanities Association, an umbrella organization tasked with the promotion of fine arts in the community. (Courtesy of Old Town Brunswick Preservation Association.)

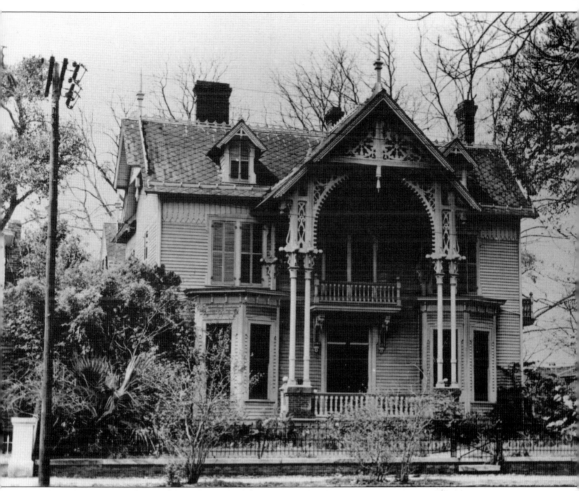

An architectural jewel, the Mahoney-McGarvey House (c. 1891) was designed by architect J.A. Wood for Timothy Mahoney, a successful railroad employee who purchased two New Town lots from the Brunswick Company for its construction. The home is noted as the finest example of Carpenter Gothic architecture in the state of Georgia; the style refers to "the variety of turned and pierced woodwork" or "airy wooden filigrees." Wood was under contract with Henry B. Plant who rivaled Henry Flagler in development schemes, both in scope and vision. Mahoney's son John met Wood when they were both working in Tampa—Wood on the design and construction of the Moorish-influenced Tampa Bay Hotel. Convinced by his son's insistence, Mahoney paid a whopping $1,000 for the plans and purchased the heart pine for his beautiful home from noted local contractors Moore and Valentino. Elaborate mantelpieces and the staircase were crafted by French immigrants Maurice and Joseph Lucree, who were paid daily. When Miss Julia Mahoney died in 1949, Virginia McGarvey inherited the Mahoney-McGarvey House where, beginning in 1956, she operated "Trendition House" until her death, stipulating that the structure be preserved. (Courtesy of Margaret Davis Cate Collection #997, Fort Frederica National Monument, Georgia Historical Society.)

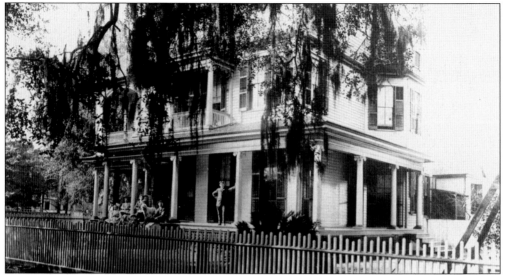

Columns and double porticos suggest classic features at #9 Halifax Square (*c.* 1890) where members of the Parker family, including the family dog, have assembled for this photograph. Leila M. duBignon Parker formerly lived and entertained her fellow charter members of the Acacia Club at this residence. It was later inhabited, from 1931to the late 1980s, by Frank L. Vogel and his wife, Leila's daughter, Mary Edward Parker (Vogel). It was sold after her death by the Parker-Vogel heirs. (Courtesy of Polly Parker Kitchens.)

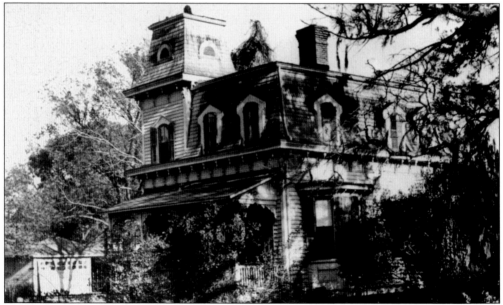

Designed and built by Dr. William Berrien Burroughs, this lovely older home located at #8 Hanover Square was owned in the late 1880s by members of the Hazlehurst family, and in more recent years by former Mayor and Mrs. Clyde Taylor Jr. An excellent example of the Victorian-era Second Empire–style, it boasts a mansard roof creating a roomy third floor. The Burroughs/Hazlehurst House shares features with Brunswick's oldest residence (*c.* 1869) located at 811 Union Street and built by Henry Riffault duBignon (seen on page 62). (Courtesy of Richard and Gini Steele.)

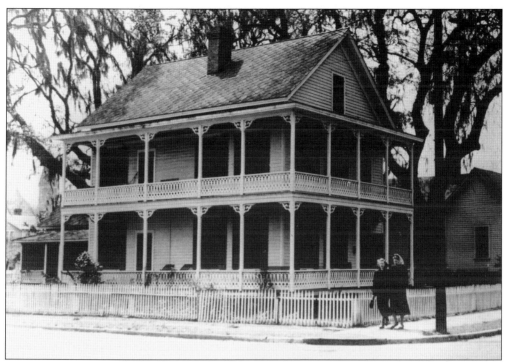

Located at 1325 Egmont Street and built by L.C. Marlin, this attractive two-story wood frame home (*c.* 1890) features double wrap-around verandas and intricate jigsaw-cut trim. Notably, a near twin house stands across the street, formerly home to beloved educator Miss Jane Macon who retired in 1952 with 49 years of service to Glynn County students—and for whom the Jane Macon Middle School, which opened in 1958, was named. (Courtesy of Richard and Gini Steele.)

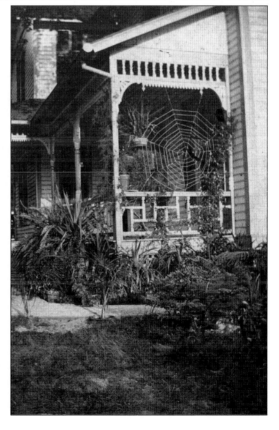

Demonstrating an ever vigilant photographer's eye, Charles S. Tait Sr. captured this close-up of a golden orb spider web and the detailed cutwork adorning the family's residence at 903 Dartmouth. A charter member of the American Camellia Society, Tait has been recognized widely for his hybridization of flowering plants and for starting the "Camellia Fancy" in Glynn County. The semi-double "Margaret Tait Ratcliffe" camellia and a ruffled rose azalea marketed as "Pride of Brunswick" remind us of his genius. (Courtesy of C.S. Tait Jr.)

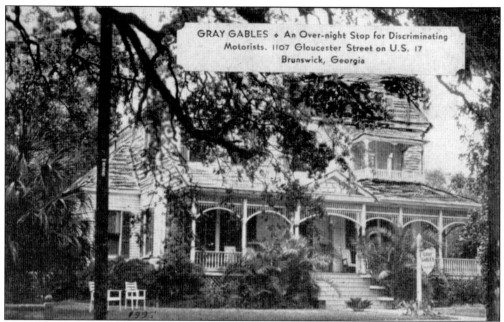

GRAY GABLES ♦ An Over-night Stop for Discriminating
Motorists. 1107 Gloucester Street on U.S. 17
Brunswick, Georgia

Developed as a postcard, the image of "Gray Gables" suggests the building's use for overnight lodging in an earlier era; for many years, it was operated as the Edo Miller Funeral Home. After the business was relocated, the property was sold, the funeral home chapel demolished, and this magnificent late Victorian home extensively restored. Reopened as Gray Gables Antiques at 1107 Gloucester Street, one more of the city's architectural treasures has been saved for new uses. (Courtesy of Jane Hildebrand.)

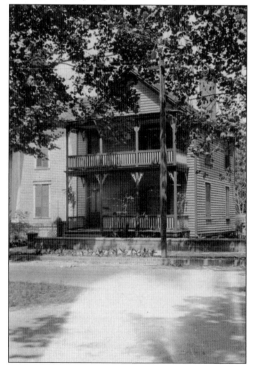

The Torras House, a two-story frame home on Richmond Street featuring double porches, once overlooked the garden setting of Hanover Park. In recent years, the property was purchased and the home where the Torras children—the celebrated artist Stella Morton and her engineer brother Fernando Torras—were born was demolished, a loss for local preservationists. (Courtesy of Robert M. Torras Sr.)

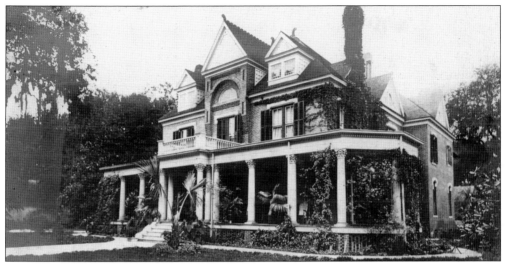

Attributed to architect Alfred S. Eichberg, this palatial home (*c.* 1886) was built of brick in the Queen Anne style by John Baumgartner for Maj. Columbia Downing. Located at 825 Egmont Street and facing Halifax Square, the Downing home featured a later addition of Grecian Corinthian columns and a porte cochere with remnants of a porch done in a delicate Exotic Revival design. Another example of Baumgartner's work, also in the Queen Anne style, stands at #1 Frederica Square. The Downing home serves the public today as a graciously appointed Brunswick Manor, the city's first bed and breakfast inn. (Courtesy of C.S. Tait Sr. Photograph Collection and C.S. Tait Jr.)

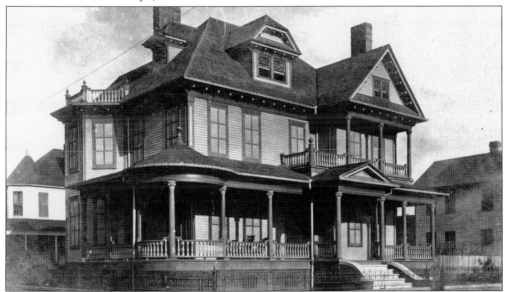

Built for lumber magnate L.T. McKinnon, this lovingly restored residence at 1001 Egmont Street dates from 1903 and reflects the popularity of the Queen Anne style in Brunswick's Old Town district. One of the most photographed residences in the area, the McKinnon House appeared in the film *Conrack,* based upon a novel by Pat Conroy. Its imposing design features complex geometric shapes seen in the gables, dormers, and veranda, with exterior cypress wood, and interior wood work of white ash and magnolia. (Courtesy of C.S. Tait Sr. Photograph Collection and C.S. Tait Jr.)

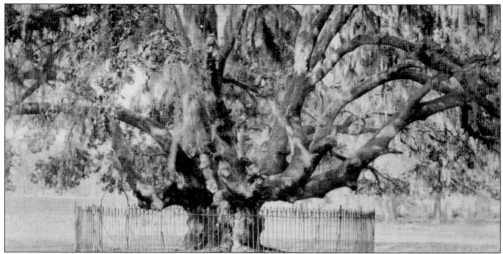

Two images of the city's greatest arboreal asset, the legendary "Lover's Oak," suggest the awe in which this hoary live oak has been held through the ages. Its reputed age of 900 years carries Native American lore—the unrequited love of a maiden for a man and a meeting spot for the two. Many variations on this theme exist, but the fact remains that tree-climbing children have found this magnificent specimen irresistible. (Courtesy of Georgia Historical Society.)

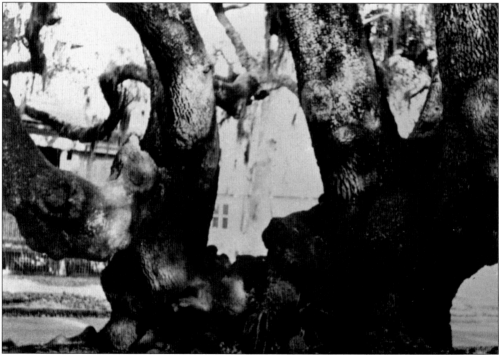

A bronze plaque presented by the American Society of Consulting Arborists, National Arborist Association, honors the Lover's Oak, located at Prince and Albany Streets. The inscription reads "The National Arborist Association and the International Society of Arboriculture Jointly Recognize this Significant Tree in the Bicentennial Year (1787–1987) as Having Lived Here at the Time of the Signing of Our Constitution." (Courtesy Margaret Davis Cate Collection #997, Fort Frederica National Monument, Georgia Historical Society.)

Janet Carruthers Leavy (1907–1992) served multiple terms (1922–1923, 1931–1947) as regent of the Brunswick chapter, National Society of the Daughters of the American Revolution. During her administrations, this old patriotic lineage organization was extremely active in erecting markers and monuments that dot the landscape and create a "sense of place" for citizenry. Located in the northeast quadrant of Queen's Square, an impressive granite Celtic Cross was erected in 1933 in collaboration with Capt. Charles Spaulding Wylly to commemorate Georgia's bicentennial year. The inscription reads "In memory of James Edward Oglethorpe Founder of the Province-Now the State of Georgia. Soldier, Philanthropist and lover of his Fellowmen, most ardently those of poor estate. Born 1696–Died 1795." (Courtesy of Stephen King Hart.)

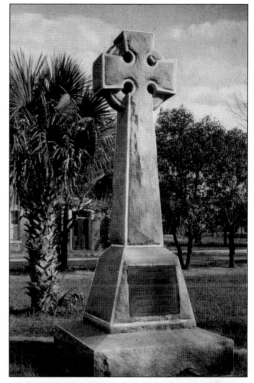

An oyster shell road, likely Lanier Boulevard in a turn-of-the-century postcard, provides a corridor traveling the fringes of the great spreading salt sea marshes of Glynn. Road builders simply recycled the large accumulations of shell from the abundant middens, or refuse piles, which once served as a reminder of the native Southeastern Indians. In the colonial era, settlers used the limey shell in combination with water, sand, and lime extracted by kiln burning to produce a coastal concrete, tabby. (Courtesy of Sara B. Ratcliffe and Bill Brown.)

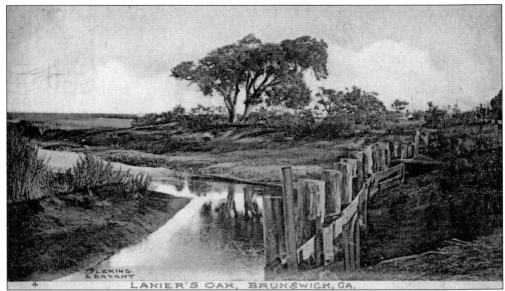

Fleming and Bryant's postcard honors the presence of a temporary resident, Sidney Lanier (1842–1881), who sought respite from a debilitating illness in the City by the Sea where he visited with his wife's Day family. Lanier aspired to an ideal serenity and immortalized "The Marshes of Glynn" in his poetry. This image provides a glimpse of how the landmark "Lanier's Oak" appeared at an earlier day. In May 1932, Mrs. Walter D. (Dorothy Blount) Lamar, president of the Lanier Association, presented a bronze tablet placed by the Macon Business and Professional Women's Club honoring a native Maconite and Lanier's genius at the spot where he penned his most famous poem. (Courtesy of Georgia Historical Society.)

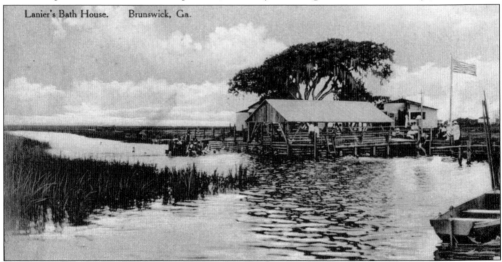

Lanier's Oak in the background marks a favorite recreation spot for Brunswickians at Lanier's Bath House and Dart's Landing. Where the concrete pillar and bronze inset were erected in 1932 remained property of the Dart family and was near the home of Judge Edwin Dart in Urbana. Accepted by city mayor J.L. Andrews, the tablet's unveiling ceremonies featured a reading of the lovely poem "Trees" written by Joyce Kilmer and acknowledged the esteem with which Brunswickians hold their arboreal assets. (Courtesy of Mrs. Sara B. Ratcliffe and Bill Brown.)

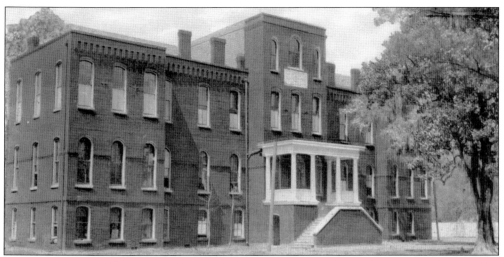

In a postcard image, the old City Hospital (*c.* 1908) stands at Norwich and Third Avenue. Holding property donated by former mayor John J. Spear, Mrs. Theodore Crovatt spearheaded a fund-raising campaign over a ten-year period between 1880 and 1890 through the Ladies Hospital Association. Her son served as attorney for the Jekyll Island Club, and when he became Judge Alfred J. Crovatt (1858–1926) and served as mayor, he sought and got a sizeable donation from the Jekyll Island Club membership, which contributed toward the City Hospital's design by Morton Marie and its construction. (Courtesy of Georgia Historical Society.)

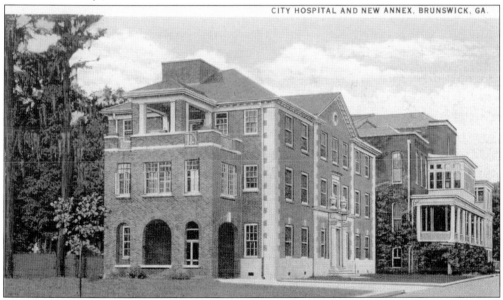

Another postcard image documents the addition of a new annex in 1928; the facility expanded again during the World War II-era, meeting the needs of Brunswick's boom town population. By mid-January 1954, the new Brunswick Hospital opened. The old city facility initially provided a home for the private Frederica Academy, but after the school moved to St. Simons, the building fell into disuse. Threatened with demolition, the Elmer Harpers purchased the property in the 1990s and restored what remained as a retirement center, in memory of their dearly beloved son, Kevin Harper. (Courtesy of Georgia Historical Society.)

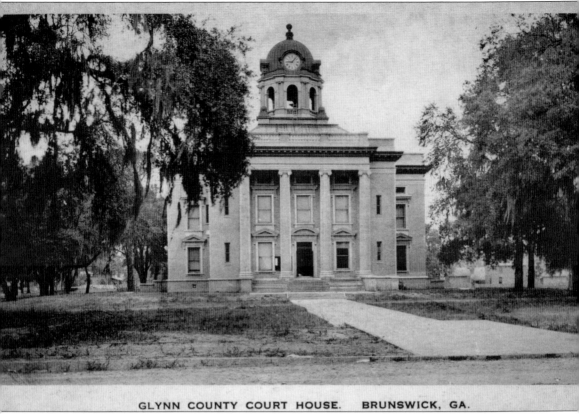

GLYNN COUNTY COURT HOUSE.    BRUNSWICK, GA.

Step back into the early 1900s and imagine the grassy, palm-lined median that created a corridor at the intersection of Gloucester and Union Streets leading northward toward the Glynn County Courthouse (*c.* 1907). Recognized far and wide as the most beautiful in Georgia, the courthouse's setting on Magnolia Square places it amidst spreading live oaks and lush landscaping. Where county affairs were once paramount, this impressive building is now sought out by tourists wanting a glimpse of its Neoclassical Revival design. It was designed by New York architect Charles Alling Gifford, whose work is notable on Jekyll Island where he served as architect for numerous private and Club projects, including Mistletoe Cottage (*c.* 1900), Sans Souci (*c.* 1896), and the Jekyll Island Clubhouse Annex (*c.* 1901). Built by an Atlanta firm, Miles and Bradt, the courthouse suggests an interlinking philosophy of justice. Four identical entrances complement interior columns leading to justice, and an intricate iron stair rail suggests her delicate balance as judged by the frailties of man. Located at 701 "G" Street, the historic Glynn County Courthouse was completed on December 18, 1907, at an estimated construction cost of $108,719. When the New Glynn County Courthouse was completed in 1991, a mall connected the two creating a center of activity for county business. Presently, the Glynn County Commission uses the old courthouse for meetings, as the facility continues to undergo a multimillion-dollar, three-phase restoration begun in the early 1990s. (Courtesy of E. Ralph Bufkin.)

In this postcard image by the New York Albertype Company, one may step into yesteryear when the old Anchorage Hotel was located at 19 Glynn Avenue opposite the St. Simons Causeway. Spacious grounds, a private lake, swimming, fishing, boating, 21 corner rooms with bath, a dining room, and free locked garages were among the amenities of this gracious hotel. It was managed by Mrs. J. Hunter Hopkins Jr. and overlooked the magnificent marshes of Glynn. (Courtesy of E. Ralph Bufkin.)

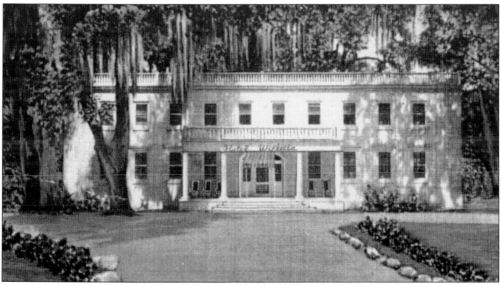

In another image, an illustrated business card serves as a reminder of mid-20th century when the old Willetta Hotel was located at 1703 Gloucester Street on the corner of Lee. A 1951 city directory advertisement billed it "Brunswick's Newest and only Fireproof Hotel," and it shared an address with H & H Service Store. In 1953, Roy and Eugenia Smith were operating the hotel ten blocks east of the city business district at Lee and Gloucester on U.S. Highway 17, rerouted with the construction of the Sidney Lanier Bridge and Jekyll Causeway. In 1957, Kermit and Dorothy Laws, owners-managers, offered amenities of air conditioning, steam heat, private baths, television, and telephones in each room at the Willetta, the "friendly hotel." (Courtesy of C.S. Tait Jr.)

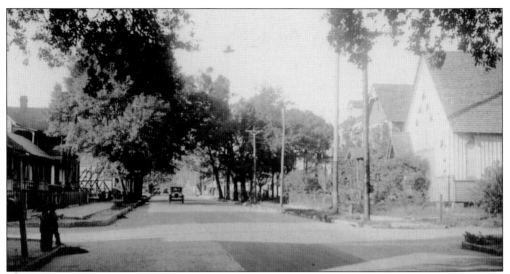

An important transportation corridor, Norwich Street featured a trolley line. In an earlier era, a "tourist route" led down Gloucester to Newcastle, north to "G" Street, and eastward to Norwich where motorists turned left, or northbound. A trolley line extended down Norwich only to "L" Street, and eventually Norwich became a dusty road when intersecting with Fourth Street. Beyond, the roadway led past the ending of the old Brunswick Canal, historic Palmetto Cemetery, and Arco. Children whose parents worked in the Atlantic Refining Company, or "Arco," filled the neatly tended yards. They lived on "Dixie Boulevard" and U.S. Highway 17, which, winding through Blythe Island via old, creaky trestle-style bridges, led south to Camden County and the Florida line. (Courtesy of Jonell Williamson Coleman and family.)

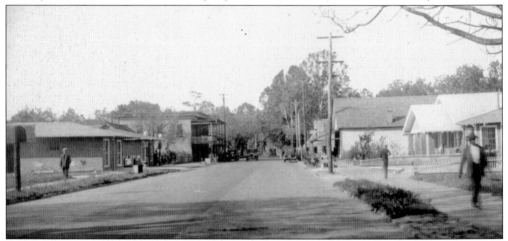

Both images face northward, though the one at the top of this page shows the 2000 block of Norwich as it intersected with "J" Street and an Episcopal church and two-story rectory on a corner lot. Residential and commercial businesses intermixed in the Norwich Street image directly above and dating from the 1930s. Kersey's Store, a two-story grocery with an upstairs veranda (far left) at "L" and Norwich, competed with Williamson's Grocery (front left), and a family lived between the two in a wood frame home. On the east side of Norwich, businesses and residences included a service station, the Barnhill's home, the Barnhill's Meat Market next door, Crosby's Drug Store, and J.B. Crosby's home. (Courtesy of Jonell Williamson Coleman and family.)

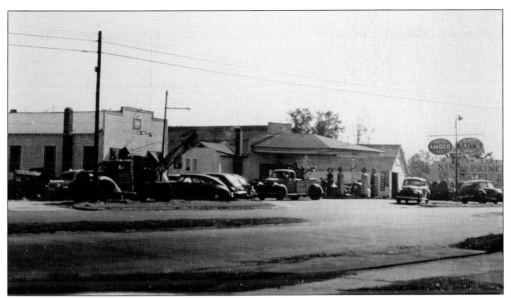

On July 1, 1938, a self-educated man, Charles S. Tait Jr., purchased a premium block of Glynn Avenue located at the entrance to the Island Causeway. Notice the signage advertising the King and Prince Hotel in the background near an Amoco sign. Initially, Tait leased a portion of the property for a cafe and operated a garage and service station selling Shell Oil gasoline. Within six months of the business opening, Tait signed up with VanDiviere Oil Company, the local distributor for Amoco. (Courtesy of C.S. Tait Jr.)

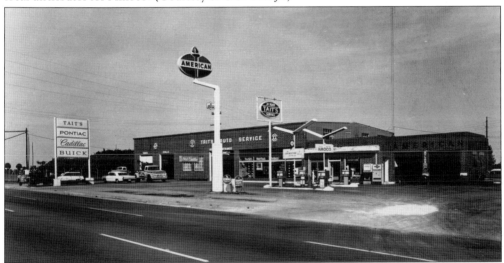

Charlie Tait sold GMC cars and trucks during the war years and offered a wrecker service. After constructing a new building, Tait held a grand opening on October 6, 1946. He sold GMC cars from the 1940s until 1954, Pontiacs from 1940 until 1974, Cadillacs from 1948 on, and Buicks from 1962 on. His landmark business closed on December 11, 1979. For 32 years, Tait's business sponsored the local radio program, "News around the Town with John Lane," featuring a trademark jingle. Initially, this program aired on WGIG Radio and made "Tait" a household word. Later, Lane and the program moved to WMOG (Wonderful Marshes of Glynn), which was dedicated on June 1, 1940 and owned and operated by Mrs. Alma W. King, a prominent Brunswick businesswoman. (Courtesy of C.S. Tait Jr.)

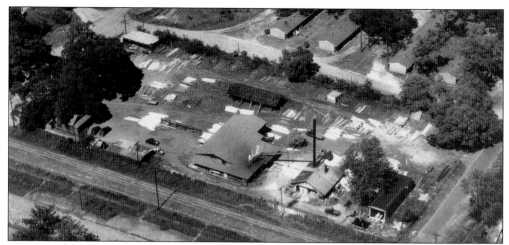

An aerial view shows one of the city's oldest businesses, Lang Building Supply (center) and 1940s warehousing (top). Located in the Dixville community at 1500 Prince Street, Lang Planing Mill was the vision of Ward Leon Lang Sr. (1869–1934). It is now operated by the fourth generation of Langs, all descendants of Isaac Lang Sr. Noted as one of the earliest settlers in Camden County, he established "Langsbury Plantation" and a small village grew around it, including a post office and stagecoach stop. His grandson Richard moved his family to Brunswick about 1885, and shortly thereafter, Ward married Lanie Horton (1870–1932) of Mt. Pleasant. Her father, George Washington Horton of Wayne County, was one of the last of the stagecoach drivers along the old Post Road. (Courtesy of John D. Lang.)

In 1930–1931, the Downing Company, Inc. advertised as "The Old Reliable." As naval stores merchants, the company offered wholesale groceries, wholesale dry goods, cooperage, and copper works, and were distributors for McCoy Cups and "new style" hacks, two items essential for woodsy turpentiners. Writing in the 1970s for *Georgia's Coastal Illustrated*, Miss Mary McGarvey described the "Dickensian setting where Dombey and Son might have done business. The tide advanced and retreated under the pilings and there were fireplaces in the offices, and there was the great dim warehouse with all the rich smells." (Courtesy of C.S. Tait Jr.)

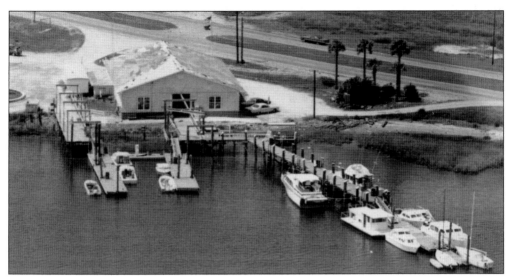

Through the years, a major commercial presence in the basin has been the old Brunswick Yacht Club, dating from 1971. After the club dissolved, Capt. "Lil Henry" Fernandes assumed a city lease in 1976 and operates the Brunswick Boat Marina to the present day. A 5,400-square-foot dry storage building features room for 22 boats, and where once ten storage spaces were available for vessels, shoaling has pared space. Two electric hoists have launched many a vessel for recreational pastime and Brunswickians recall those days when skiing was commonplace in the basin. (Courtesy of Henry Fernandes.)

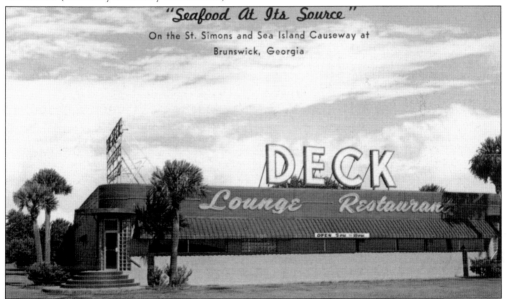

Brunswick Boat Marina anchors the south side of Lanier Basin and, until November 1999, a shell of the formerly prosperous Art Deco–style Deck Restaurant and Lounge stood at the entrance to the F.J. Torras Causeway leading to the islands. Featuring a maritime theme, the main dining room replicated a yacht's deck. This postcard image noted the special seafood dishes, such as "Shrimp Mull," and tasty concoctions enjoyed by coastal residents and visitors to Brunswick–Glynn County. With a seating capacity of 400, the Deck Restaurant served as a landmark from its opening in 1946 to its demolition. (Courtesy of Stephen King Hart.)

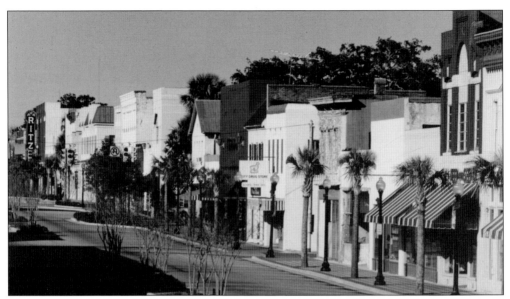

A photocard image sweeps northward on a Newcastle Street corridor capturing the renovation and restoration projects afoot downtown. During 1986, this initiative began in earnest when the Downtown Development Authority (DDA) formed, subsequently followed by a Main Street Program in 1987. In June 2000, the DDA achieved national recognition through Brunswick's certification as a National Main Street Community. Revitalization within downtown and the restoration of old homes within the national register Old Town Historic District promise locals and future generations a bright future. Brunswickians anticipate an enhanced quality of life with the completion of the "New" Sidney Lanier Bridge and a golden "Bridge to the Future" seen below in a dramatic aerial view of the port. (Courtesy of Ed Mathews.)

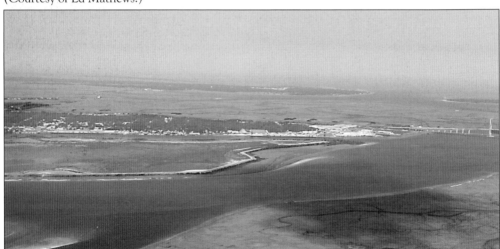

In this dramatic sweep of Colonel's Island and Port of Brunswick dating from August 2000, notice background features and the Brunswick waterfront. Import and export of automobiles and an enhanced, sophisticated agri-bulk facility create a bustle of activity at the Colonel's Island Terminal. Complementing the Georgia Ports Authority's operation at Colonel's Island are their Marine Port Terminal facilities located along the East River, handling commodities such as gypsum, limestone, perlite, and salt. (Courtesy of Harlan Hambright.)

# *Four*

# PEOPLE

*Men and women of great foresight and vision have left their footprints on the sands of Brunswick–Glynn County, and a few of these people appear across these pages. These inspiring role models created examples not only for their children and their descendants, but for their peers as well; in doing so, they contributed toward the common good in our world by the sea. Whether passionate about preserving and researching the richness of our history, perpetuating vestiges of dying cultures, upholding the law, or building or designing, a common thread exists—zeal for their work and for whatever tasks they faced.*

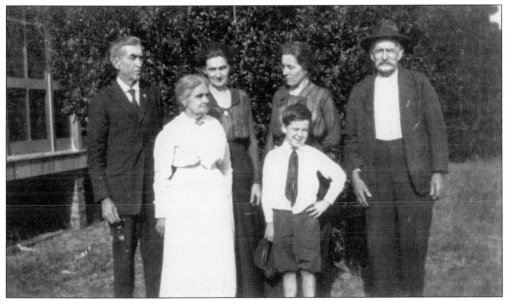

Members of the Burford-Stallings family pose on November 27, 1919, in this rare photograph. Seen from left to right are (front row) Mary E. Teppe Stallings, second wife of Captain Stallings; and eight-year-old Howard Edward Burford, who later served in the Armed Forces in World War II and became an attorney; (back row) dearly beloved Dr. Robert E. Lee (R.E.L.) Burford (1861–1932); his wife, Emma Gertrude S. Burford (1874–1957); her sister Lila Stallings (1871–1967), a long-term educator who served as principal of the Sidney Lanier School for over 20 years; and their father, Capt. "Docky" Stallings, CSA (1841–1923). Dr. Burford served as the sanitary inspector for the U.S. Marine Hospital Service at Quarantine Island where Docky Stallings lived and worked for numerous years. (Courtesy of Mrs. George H. Cook Jr. and Fred Cook.)

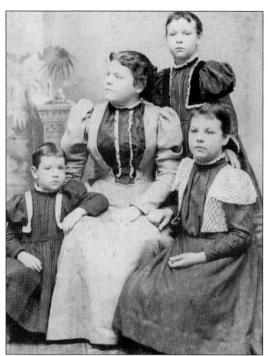

The following two images show members of the Dart family, whose history intertwines with Brunswick. They are the descendants of a city father, Urbanus Dart, seen on page 12. The children of William Robert Dart, CSA (1847–1925) by his second wife, Mary Cordelia Grey (Dart) (1876–1906), from left to right, are Ethel Grey Dart (Brown) (1892–1970); Sara Ellen "Sadie" Dart (1879–1959), who reared the children when their Mother died; Mollie Robert "Robbie" Dart (1889–1920); and Janey Cordelia Dart (1886–1945), RN. Members of this family rest in both city cemeteries, historic Oak Grove Cemetery dating from September 1839 and Palmetto Cemetery. (Photo by R.H. Winston; courtesy of Sara B. Ratcliffe and Bill Brown.)

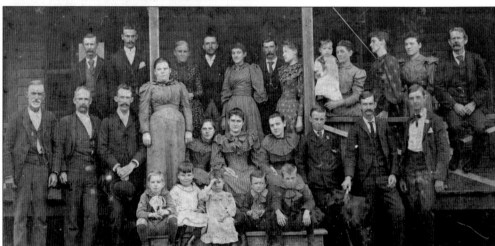

Twenty-seven members of the Dart family gathered for an unspecified occasion, c. 1894, perhaps in celebration of a rite of passage, or a special event, or a religious observance unknown at this writing. Pictured from left to right are (front row) Horace Symons, Janey and "Robbie" Dart, unidentified, and Johnny Symons; (middle row) Fred Symons, W.F. Symons, Edwin Dart, Lulia Dart, Gertrude Stallings, May Dart, Sadie Dart, unidentified, W.R. Dart, and unidentified; (back row) Francis W. Dart, Leroy Dart, Mrs. Horace Dart (Hattie Ashcraft), L.A. Fleming, Emma Symons, Willis Dart, Evie (Evelyn) Dart, Ethel Dart, Mrs. W.R. (William Robert) Dart, Mrs. W.F. Symons, Miss Lila Stallings, and her father, Capt. D.B. "Docky" Stallings, CSA, widower of Sara Dart Stallings (1843–1881). The Stallings girls were reared by their relatives, the Wilfred Symons at St. Simons Mills, after their mother Sara's death, while their father superintended the Mills. They appeared with their father and on page 55. (Courtesy of Sara B. Ratcliffe and Bill Brown.)

Hailing from a family of explorers and navigators dating from Sebastian Cabot, Rosendo Torras (1851–1929) was born at Arenys de Mar near Barcelona, Spain. His education through the University of Barcelona and the School of Navigation in Arenys de Mar prepared him for his life's work and extensive world travels. In Brunswick, he met and married Mary Lucy Minehan (1854–1889), a large property owner in the south end of Brunswick. They had a number of children whose names prominently appear on the landscape, including artist Stella Torras Morton and engineer Fernando J. Torras. After his first wife's death, Captain Torras remarried Katherine Fenton Calnan (1859–1933) and one of their children, Elvera Torras, can be seen on page 100. (Courtesy of Beverly Wood Hart.)

Gifted in creative and inventive ways, Torras wrote in idiomatic Castillian and proved a visionary and progressive businessman. Both Torras's wharf and consular office occur in other images and furnish insight into his participation in Brunswick's "Golden Era of Sailing Vessel Days." In 1905, King Gustaf of Sweden honored Torras as "Knight of the Vasa," or Knight of the Green Ribbon, for distinguished services to the Swedish Crown. Hence, a man of the Brunswick waterfront served in diplomatic circles as Sir Rosendo Torras. (Courtesy of Beverly Wood Hart.)

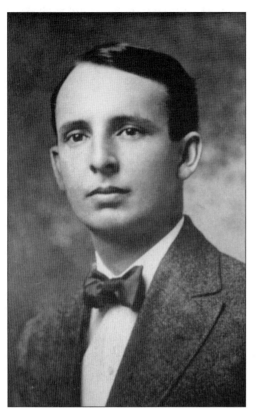

Reared in a family who appreciated global travel, Fernando Joseph Torras (1885–1952) honed his knowledge and skills while working at the headwaters of the Brazilian Amazon, creating the Madeira-Mamore railway. He applied learned techniques to the soft salt marshes of Glynn and, with backing from New York bankers, built the F.J. Torras Causeway, irretrievably altering prospects for two pearls in Georgia's chain of barrier islands. Paid for by local revenue bonds, the 6-mile causeway cost $418,305, and after 13 months, the enormous "impossible" project was completed in July 1924 to great fanfare. Many locals assisted with this engineering feat, including among others, Cusie Sullivan of the Harrington Community who served as Torras's rodman. F.J. Torras served as city manager of Brunswick for over 30 years and was involved with the layout of Sea Island and many other development plans, including the historic El Dorado subdivision on St. Simons Island. A marker at the intersection of Gloucester and Newcastle Streets reminds passersby of the esteem in which Torras held the spreading, great live oaks. (Courtesy of Robert M. Torras Sr.)

Born in New York, Alfred S. Eichberg (1859–1921) moved south with his parents in the late 1860s and, in 1881 when he was about 22 years old, formed an architectural partnership, Fay and Eichberg. By 1884, the firm was established in Savannah and Eichberg allied his practice with Witcover. His penchant for port cities establishes him as a "coastal architect" working in Wilmington, North Carolina, where he designed the New Hanover County Courthouse (c. 1892). In Savannah, he served as architect for both commercial and residential structures, notably the Central of Georgia Railroad building (233 West Broad Street) and the J.S. Wood residence (803 Whitaker Street). In Brunswick, two public buildings demonstrate his genius, Old Prep High (c. 1890) and Old City Hall (c. 1889). (Courtesy of Carolyn E. Lazarus.)

When he was ten years old, Leo Lomm (1856–1939) left his homeland in Neder Kalix, Sweden, following the lure of the sea; his adventurous nature kept him on sailing vessels until he was 20 years old. He disembarked at Saint Mary's, Georgia, and later worked for the L'Engle family in Jacksonville. In Brunswick, he worked aboard the tugboats *Angie and Nellie*, built in the port city and owned by the South Atlantic Towing Company, and the fast vessel *Dauntless*. Recognized as an accomplished mariner, Capt. Leo Lomm served as "Commodore" of the fleet when he captained another fast, 100-foot tugboat, the *Edgar F. Coney* seen on page 24. (Courtesy of Capt. Leo Ross.)

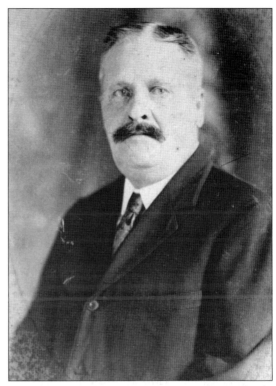

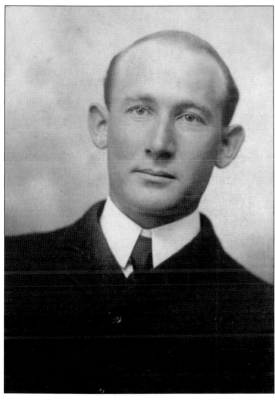

Born in Glynn County to John C. Hotch and Mary E. Furlong (Hotch), Capt. John Theodore Hotch (1877–1952) learned seaworthy skills at his father's knees, and their combined maritime activities spanned over 100 years. Locals, such as Capt. Leo Ross, learned from Hotch aboard a vessel considered the workhorse of the port in earlier days—the *Inca*. Serving as tugboat captain with the South Atlantic Towing Company, Captain Hotch was employed for over 40 years by the Coney and Parker Company. Active in the First United Methodist Church, Captain Hotch was also a member of the old Propeller Club of the Port of Brunswick. (Courtesy of the Hotch family.)

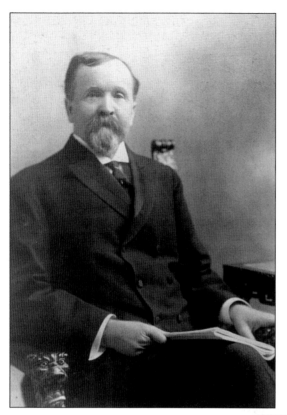

Born into a prominent Meigs County, Ohio, family, Columbia Downing (1845–1924) came south with a precursor of the Standard Oil Company, the Chess Carley Company. As company representative both in Atlanta and in Savannah, he traveled from the Piedmont to the coast and pursued the naval stores business. Incorporated in 1890, the Downing Company achieved unprecedented prosperity, and by 1902, the naval stores factorage house had placed Brunswick on the map as the second largest shipping port in the world for naval stores, the leading for crossties. Downing served as president of the First National Bank and of the fledgling Board of Trade, and as a director of the Oglethorpe Hotel Company. His philanthropy was legendary and he thrived during a period of great confidence in our country's potential for growth and development. (Courtesy of Richard and Gini Steele.)

Born at Longstreet Community near Cochran, Georgia, Edward Hodges (E.H.) Mason (1865–1922) left Middle Georgia as a young man to seek his fortune on the Georgia coast. In Brunswick, he followed the difficult administration of Mayor Thomas W. Lamb, who confronted both a depression and a devastating yellow fever epidemic. Mason served two terms in office as mayor from 1896 to 1903, when Judge Alfred J. Crovatt assumed office. Mason operated the ship chandlery business of E.H. Mason and Company, catering to the needs of a bustling port. He served on the board of directors for the National Bank of Brunswick, organized by Columbia Downing. In 1910, Mason was appointed president of the National Bank, the precursor to both the old First National Bank of Brunswick and today's Sun Trust Bank. He served as president for 12 years, from 1910 until his death. His portrait hangs in the Board of Directors' Room. (Courtesy of Ed and Breeden Liles.)

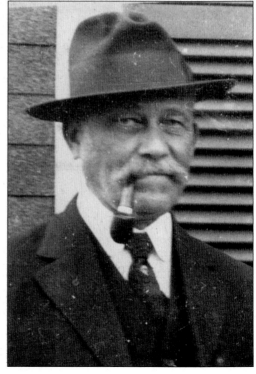

When opportunities were ripe for moving from Gastonia, North Carolina, Charles Spottiswood Tait Sr. (1861–1939) brought his bride, Margaret, to Brunswick. His multifaceted personality sought expression through photography and horticulture, while for over 40 years he managed the wholesale grocery operation of the Downing Company. Tait's collection of over 1,000 glass lantern negatives captured images of Brunswick and a bird's-eye view of life at the turn of the century. Heralded as the "second Luther Burbank," he was nationally recognized for his plant hybridization of bulbs and the lovely Camellia Japonica. For numerous years the family business, Tait Floral Company, Inc., set the standards by which others were judged. (Courtesy of Margaret Tait Ratcliffe and C.S. Tait Jr.)

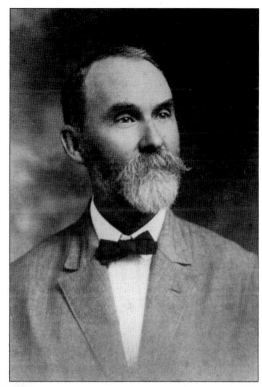

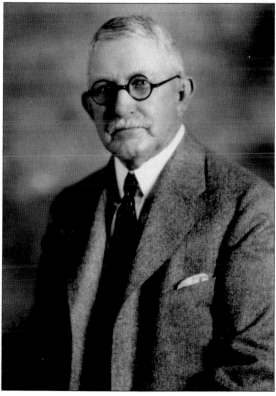

Another North Carolinian from Wilmington, Alfred Vincent (A.V.) Wood Sr. (1853–1926) moved to Brunswick in 1877. Following a career with the naval stores industries that spanned nearly 60 years, Wood worked as manager of the Downing Company's yard for 36 years. His strategic position in such a lucrative business empowered him to contribute in humanitarian ways to his community. His service on the Glynn County Board of Education spanned 25 years, during which period he personally financed teachers' attendance at the traveling Chautauquas that visited the City by the Sea. Dynamic and diverse interests and a civic-minded nature characterize this remarkable man. (Courtesy of Clara Marie Gould.)

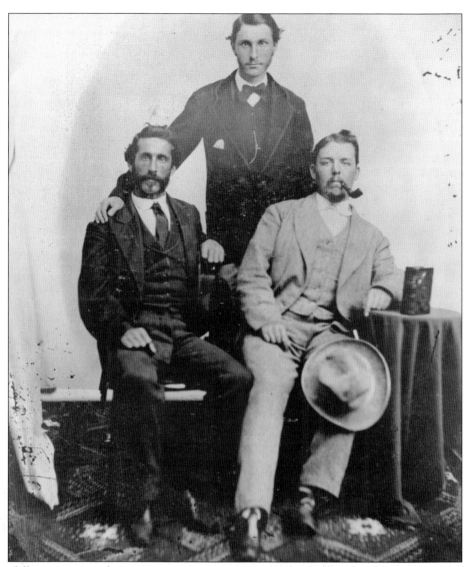

The following series of nine images creates a portrait of a family, the duBignons and their descendants. Their ancestor and patriarch, an adventuresome seafaring captain, Le Seur Christophe Poulain De La Houssaye duBignon, and his bride, Margaret, sought a land of liberty and fled the French Revolution. He acquired full title to Jekyll Island on October 14, 1800. Christophe settled his family on the north end in the handsome tabby house formerly occupied by the colonial Capt. William Horton and pursued the coastwise trade for a livelihood. In this image of the third generation, John Eugene duBignon (1849–1930) places his hand on the right shoulder of his brother Henry Riffault duBignon (1843–1872) as the two pose with their brother-in-law, W.F. Stewart. Through shrewd maneuvering, a profitable marriage, and by teaming up with his sister Josephine's husband, Newton S. Finney of New York (who brokered the sale of Jekyll Island to a group of northern investors), duBignon was assured of lasting prominence and wealth. His savvy public relations campaign featured Jekyll as a "huntsman's paradise" and although the entrepreneur John E. duBignon was the sole Southerner listed on the roster of the Jekyll Island Club, with the sale of his extended family's birthright, the duBignons removed to the mainland. (Courtesy of Polly Parker Kitchens.)

Daughter of pioneer Glynn County residents Henry R. duBignon and Alice Symons (duBignon), Leila Madeleine duBignon (1869–1941) married William Foster Parker on April 21, 1891. Period news announced "The Bell's Ring" and provided details on their marriage by Rev. Henry E. Lucas at St. Mark's Episcopal Church in an evening ceremony that began at 8 p.m. Heralded as "one of the most brilliant weddings Brunswick has ever known," musical arrangements performed by Professor Conrad Wirtz began as he played Batiste's Processional, followed by Mendelssohn's wedding march. Leila carried a bouquet of white roses and wore a stunning gown of white china silk with Valenciennes lace. Eight bridesmaids wore simple but lovely costumes of white organdy and each set of two carried a bouquet of white roses, yellow roses, pink roses, and red roses. Both bride and groom were prominent members of two of Brunswick's oldest families. (Courtesy of Polly Parker Kitchens.)

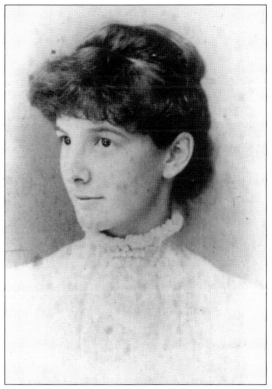

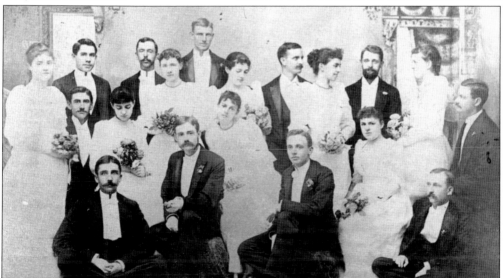

Their bridesmaids and groomsmen hailed from old established coastal families—Zoe Symons with Edward Parker, Margaret Stiles with H.F. duBignon, Bessie Parker with James Beckett, Mai King with C. Don Parker, Buford King with R. Wayne, Katherine Stiles with Morrel Symons, Flo King with Mr. ? Troup, and Mamie Burroughs with F.O. Ticknor. When Leila and William Parker departed on the train for a Texas honeymoon in Galveston, the tug boat *Inca* blew a fog horn saluting the newlyweds as the train moved down Bay Street. (Courtesy of Polly Parker Kitchens.)

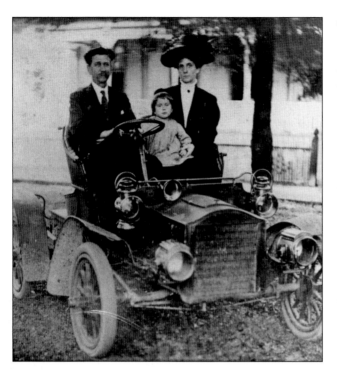

The Parker home at #9 Halifax Square is in the background of this family photograph featuring William F. Parker, his wife, Leila, and their daughter Mary Edward Parker (Vogel). Period news accounts note that their new one-cylinder model 1902 Cadillac was the first automobile in the City by the Sea. When they married, he was affiliated with Coney and Parker, which did towing for the port. In 1907, he served as secretary-treasurer for Parker-Hensel Engineering, and by 1924 was president of Coney and Parker Company, dealing in coal, wood, and other building materials. (Courtesy of Polly Parker Kitchens.)

Firstborn son of Leila and William F. Parker, William Hyde "Bill" Parker (1892–1933) followed in the entrepreneurial footsteps of his ancestors. In September 1917, he married May Elizabeth Ann Wright (1893–1972), widely known as May Wright Parker, and their descendants live today within the city or along the coast. As a leading young businessman, Parker worked with a real estate and brokerage firm, Fleming and Parker Company and, in December 1926, assumed duties as office manager for Sea Island Investments, Inc. while the company planned the development of Glynn Isle (Sea Island). At his untimely death, he served as president of Parker Realty Company, Wright and Gowen, and Wright and Parker, as secretary and treasurer of Dixie Investment Company, as secretary of the Georgia Coastal Hotel Company, and as director of the Brunswick Bank and Trust, as well as being an active member in local civic organizations and St. Mark's Episcopal Church. (Courtesy of Polly Parker Kitchens.)

In a cherished image, sixth generation duBignon descendants and first cousins William Wright Parker and Alice Woodcock (Lane) pose for the camera. Wright Parker has continued the operation of the family business, Parker Realty, established in 1926 by his father, Bill Parker, when the former firm of Fleming and Parker Company dissolved. Widow of the popular local WMOG radio personality John Lane (1920–1994), who brought the coastal community "News Around the Town," Alice worked for many years as an accountant for the long-established Cunningham Jeweler's, Inc., at 1510 Newcastle Street. (Courtesy of Polly Parker Kitchens.)

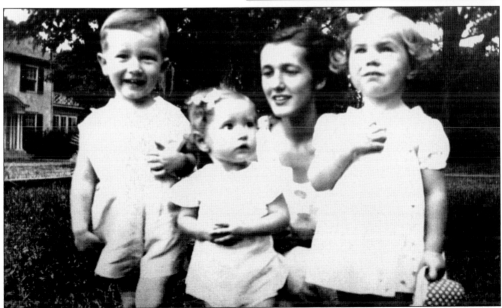

Seventh generation duBignon descendants, four first cousins pose for the camera. Seen from left to right are Frank Willard "Woody" Woodcock Jr. (1935–1973), Polly Parker (Kitchens), Alice Woodcock (Lane) at "sweet sixteen," and Mary Parker Vogel (McClelland), lovingly known by the family as "Bunchy." (Courtesy of Polly Parker Kitchens.)

In her large collection of family photographs and memorabilia, Polly Kitchens saved an image of the Parker family's dearly beloved domestic servant, Hattie Lamb. She was a fixture in their household and had worked for her grandmother Leila duBignon Parker, for her parents, Mr. and Mrs. Harry duBignon Parker, and for her first cousin, Alice Woodcock Lane. (Courtesy of Polly Parker Kitchens.)

Posing for local photographer Charles Ragland aboard the vessel *Harry D. Parker*, from left to right, are the captain's unidentified daughter, Woody Woodcock, and his cousins, Laura Parker (Carrico) and her only sibling, Polly Parker (Kitchens). Next to the Parker girls is their father, Harry duBignon Parker (1898–1969), formerly president of the old family firm, Coney and Parker, and a multi-term member of the Glynn County Board of Education. (Photograph by Charles E. Ragland; courtesy of Polly Parker Kitchens.)

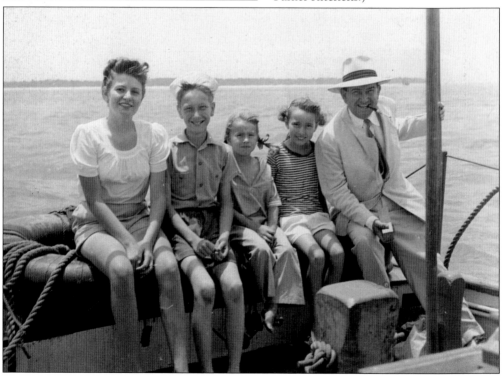

Pictured from left to right are Lydia Austin Parrish (1872–1953) and the redoubtable coastal historian Margaret Davis Cate (1888–1961). Credited with saving the old work and play songs that appeared in her 1942 book, *Slave Songs of the Georgia Sea Islands*, Parrish contributed to ethnomusicology and perpetuated vital oral traditions of the Carolina-Georgia coastal "Gullah" culture. She lived in a modest cabin at Kelvin Grove and initially listened to the lyrical music of her domestic helper, "Miss Julia" Proctor Armstrong, while her illustrator husband Maxfield Parrish (1870–1966) created whimsical images of enduring appeal in Cornish, New Hampshire. Possessed of the ultimate "sense of place," the tireless historian Cate collaborated with Parrish and likely facilitated her contacts within a closed community. Cate's book and Orrin Sage Wightman's photography in *Early Days of Coastal Georgia* (1955) documented coastal African-American funerary art such as no other. Dating from the 1930s, Cate's zeal for collecting and preserving coastal history became legendary. As Glynn County historian, she wrote the text for many of the commission markers seen today along Brunswick-Glynn roadways. Serving as historian for the Brunswick chapter, DAR, Cate facilitated the erection of markers and monuments which dot the coastal landscape in Liberty, Glynn, and Camden Counties. She played a dominant role in establishing Oglethorpe's old fort at Frederica as a national monument in May 1936. (Courtesy of Margaret Davis Cate Collection #997, Fort Frederica National Monument, Georgia Historical Society.)

Two images capture a lovely Mary Ross—at the family home on Norwich Street and on a family outing at Half-Moon, known today as Satilla Shores subdivision near Colonel's Island. Born into a family with close connecting ties to the sea, Mary Letitia Ross (1885–1971) as a young child absorbed the mystique of coastal Georgia. Reared in a family that placed high value on education, she pursued college-level degrees and a passion for the history of Spanish Colonial Georgia, which in the early 20th century was not well documented. In 1922, her mentor, Herbert Bolton of the University of California, Berkeley, predicted a stellar future for his protege, Mamie Ross. She would put Spanish Colonial Georgia on the map and "be the historian of the Anglo-Spanish contest for Georgia." A controversial book jointly published in 1925 by the two, titled *The Debatable Land,* misidentified certain tabby ruins as relics of Spanish missions. One of many myths associated with coastal living, the origin of limey tabby ruins was disputed by a rising star at the University of Georgia in Athens. Based upon a collection of edited essays, Dr. E. Merton Coulter produced *Georgia's Disputed Ruins* in 1937, refuting the tabby mission theory. Bolton allowed Ross to bear the brunt of criticism, and although she collected an enviable accumulation of documents from the Archives of the Indies in Seville throughout her life, Ross never again published her work. The City Park and Tree Commission honored Mary Ross's efforts to beautify Hillary Square near 1518 Norwich Street where she lived in retirement. When a nearby business expanded into the beautified square and 1500 block of Norwich Street, the Park and Tree Commission searched for a suitable area to rededicate a "Mary Ross Park" within city boundaries. Dedicated in July 1989, the Mary Ross Waterfront Park is now the site of many community activities (Courtesy of Lois F. Ross and Capt. Leo Ross.)

Hon. Judge Orion L. Douglass holds the distinction of being the first man of African-American descent to serve as an elected judge of State Court, only the tenth jurist in this position. Created in 1895 by an act of legislation in the General Assembly, the State Court was originally called the "City Court of Brunswick." The first judge, Samuel Carter Atkinson (1864–1942), seen at right, presided from 1896 to 1900. He was the ninth child and youngest son of the prominent Alexander Smith Atkinson family of Camden County and grandson of former governor Charles J. McDonald (1839–1843). Judge Atkinson served the longest tenure to date on Georgia's State Supreme Court, from 1906 until his death. Notably, he upheld the doctrine of *stare decisis* (to abide by or adhere to decided cases) and was adamant about the importance of construing the law so that a law-abiding citizen had no doubt about the correct path. (Courtesy of Glynn County State Court.)

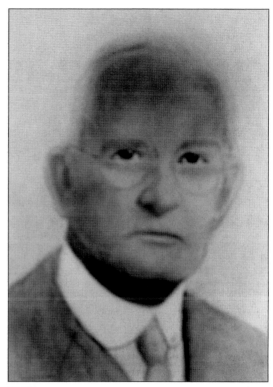

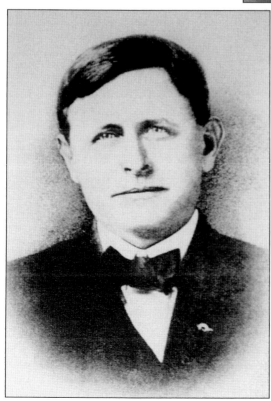

One of Judge Alvan Davis (A.D.) Gale's (1870–1918) descendants wrote about indomitable spirits, men wreathed with laurel "who have felt the thorns of circumstance. Valiant warriors, their like come not that often among us." Stenographer in a prominent law office and later for the City Court, the future Judge Gale "read the law" and, after meeting all requirements, began his practice. In 1903, he was appointed judge of City Court by Gov. Joseph M. Terrell (1902–1907) and followed the judgeship of Judge J.D. Sparks (1900–1903). Known for integrity and high mindedness, Judge Gale was equally possessed of a patriotic nature and was an accomplished orator. On the day of his death, he made three platform speeches amidst Armistice Day celebrations, November 11, 1918. (Courtesy of Glynn County State Court.)

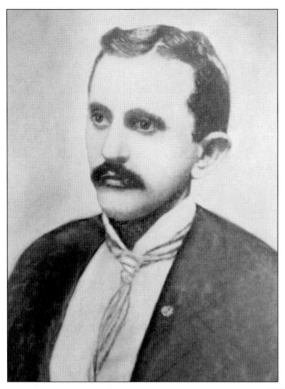

Graduated from the venerated Glynn Academy and seen on page 114, Daniel Webster (D.W.) Krauss (1869–1949) also "read the law" and was a practicing attorney for nearly 60 years. Active in Brunswick politics, he served on the city council, as well as three four-year terms as judge of City Court (1907–1919). He was known for his equity in civil and criminal matters in pursuit of justice for all. He derived great strength of character from poetry and had a great appreciation for the beauty of rhyme. (Courtesy of Glynn County State Court.)

Convivial, eccentric, flamboyant, and one of Brunswick's most colorful characters, Judge Eustace Chisolm Butts (1875–1946) served the longest (1919–1944) of any judge in the more than 100-year history of State Court. Politics and a social nature came naturally for him. Representing Brunswick–Glynn County in the state legislature (1902–1906), he later served as mayor (1912–1914), was a member of the Glynn County Board of Education (1910–1914), and juggled an impressive record of community service and involvement in fraternal organizations. As Captain Butts of the World War I–era "Brunswick Riflemen," he returned to small-town Brunswick a war hero, and legend holds he volunteered this military contingent to chase the revolutionary Doroteo Arango "Pancho Villa" out of Texas and back into the state of Chihuahua! Assisted by Willie B. Bryant, he held midweek soirees at his Blythe Island country home, offering sumptuous coastal suppers. Bill of fare included wild game and seafood, and Judge Butts's famous "Shrimp Mull Blythe Island." (Courtesy of Glynn County State Court.)

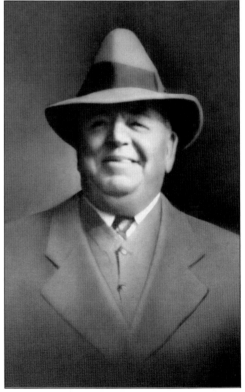

In 1943, Glynn County's representatives in the Georgia legislature, Charles L. Gowen and John Gilbert, proposed legislation that created a Constitutional City Court. One of the longest sitting judges, Judge W.C. Little (seen here) received appointment by Gov. Ellis Arnall (1943–1947) and served as judge of the City Court of Brunswick from January 1, 1945 to December 31, 1968, when he retired from the bench. For 11 of those years, his son Wilbert N. "Bill" Little served as solicitor. Upon his father's retirement, Bill ran for the judgeship, was elected to the bench, and after serving from 1969 to 1972, did not seek re-election. The name of the court changed twice during his four-year term, and later state legislators created uniform jurisdiction by changing all the old city courts, state-wide, to state courts. Two other former State Court judges, Hon. Eugene "Gene" Highsmith (1973–1979) and Hon. Ronald D. Adams (1979–1992) are living today. (Courtesy of Glynn County State Court.)

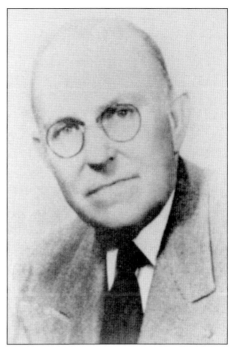

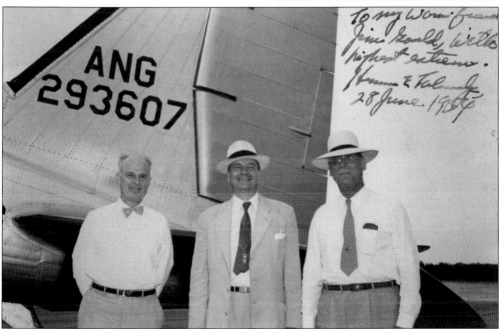

Pictured from left to right are Sea Island Company's Alfred W. Jones Sr., Georgia Gov. Herman Talmadge (1949–1955), and Talmadge's good friend and cohort, Col. James D. Gould Jr. at the Malcolm McKinnon Airport on St. Simons Island. In a solidly South Democrat Georgia, Atlanta was good to Glynn County, and in June 1956, the "new" Sidney Lanier Bridge opened, spanning the South Brunswick River and creating a new north-south corridor via Highway 17, opening Jekyll Island and the former "Millionaire's Playground" to all Georgians. (Photo by Ed Friend; courtesy of James D. Gould III.)

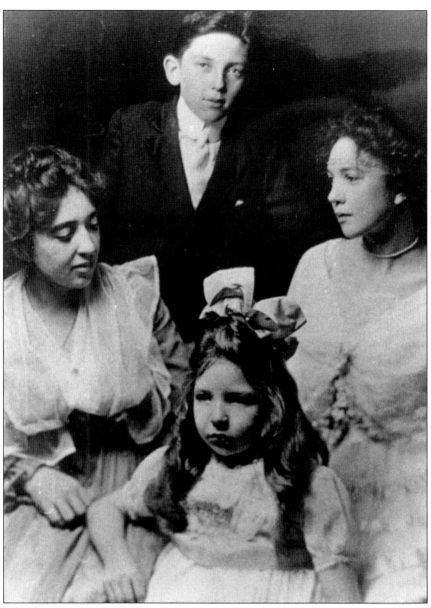

Shepherded by their brother, Cormac McGarvey Sr., the sisters McGarvey pose in a classic portrait of a close-knit family who made legendary contributions to the Brunswick–Glynn County community. Mary Pauline McGarvey (1908–1999) sits between her two beloved sisters—on the left, Virginia Mary McGarvey (1893–1986), and on the right, poetess Margaret Ann McGarvey (1899–1962). Margaret's secretarial skills served not only the manager of Hercules Powder Company for 38 years, but the Brunswick Community Concert Association (BCCA) for 22 years as well. Both Virginia and Margaret were charter members of the BCCA and the Little Theatre of Brunswick, as well as being office holders. Virginia's business acumen was reflected in the Trendition House discussed on page 39. After her untimely death, Margaret's surviving siblings memorialized her through the publication of a posthumous work, *D\*Dawn and Other Poems* (1964). They also sponsored the annual "Allegro Poetry Contest" in local high schools from 1963 to 1991. (Courtesy of CGHS.)

Born in County Donegal, Lerman Parish, Ireland, the progenitor of the McGarvey family in Brunswick Cormac Augustus McGarvey (1857–1930) followed opportunity from Philadelphia to Georgia, via coastal Carolina, where he married Carlotta Pauline Robinson (1868–1939) in Beaufort. In Brunswick, he established C. McGarvey, Inc., as a furniture emporium dating from 1886 and offering upscale fine furnishings, handsome show windows, reserved warehouse stock, and two floors of shop stock. McGarvey also served as a Brunswick city councilman. After his death, his oldest daughter, Virginia, carried on the family tradition and a love for elegance and fine furnishings. The business was relocated in the mid-1950s from the 1300 block of Newcastle to 1709 Reynolds Street, the address of one of the city's finest mansions. Virginia McGarvey, assisted by her sister Mary, operated the Trendition House from the opening of the new decorating department on March 1, 1955, until her retirement after 1984. (Courtesy of Cormac McGarvey Jr.)

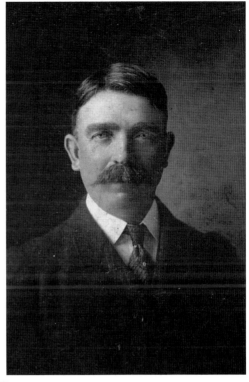

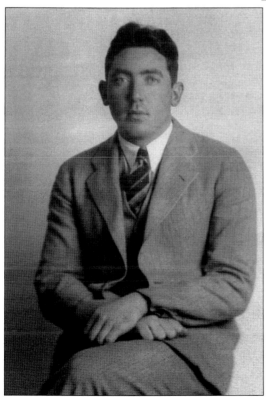

The son of Cormac Augustus, Cormac Murray McGarvey Sr. (1902–1991) held rankings on a state and national level as an accomplished tennis player but left his mark on the landscape through his architectural work. Graduated from Glynn Academy, Georgia Tech, and with further studies at the Fontainebleau School of Design in Paris, McGarvey worked in New York City and as an engineer in Central America. In Glynn County, as a young architect he designed the St. William's Catholic Chapel in the Spanish mission style on St. Simons Island, Duke and Murhee contractors, furnished by the Ladies' Altar Society of Brunswick. Public buildings bear his mark, including the "New Casino" on St. Simons, Altama Elementary School and Jane Macon Middle School, the old American National Bank, and Oak Park Motel, as well as numerous private residences on St. Simons, Jekyll, and Sea Islands. (Courtesy of Cormac McGarvey Jr.)

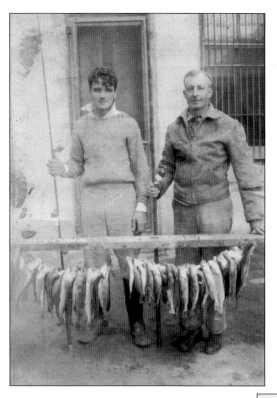

From left to right, Brunswick businessman and jeweler Henry Cate (1916–1998) poses in a Reynolds photograph with his friend Sidney H. Nathan (1894–1969) behind Pfeiffer's Grocery Store at 1329 Newcastle Street. Cate savored "the length and the breadth and the sweep of the marshes of Glynn" and was a lifelong outdoorsman and avid angler who saved time away from his avocation for his high school sweetheart and wife of 60 years, Eleanor Burdet Stiles Cate. In April 2000 the state Board of Natural Resources adopted a resolution re-naming a 160,000-square-foot artificial reef on the northwest side of Jekyll Island as the Henry Vassa Cate Fishing Reef, honoring him and his contributions to the state's scientific studies through a fish tagging program. (Courtesy of Eleanor Stiles Cate.)

Maude Gibbs Lambright (1889–1969) was a native of Bath, Maine, and moved with her family to Brunswick where she met and married Joseph Edgar Lambright (1886–1971). For many years, he served as editor of the weekly paper the *Brunswick Pilot*, the official organ of Glynn County in 1933; however, Lambright and his business partners, A.S. Glover and T.E. Glover, closed the paper when World War II rationing began. Maude served as the society editor and must have benefited from her involvement in the "Friday Afternoon Club" as read in her writings. She was a charter member of the Woman's Club of Brunswick and the Brunswick chapter, American Red Cross. Notably, Maude Lambright was the first director of the Glynn County Welfare Department, today's Department of Family and Children Services, Georgia Department of Human Resources. While she served as director for 25 years, Lambright collected extensive genealogies on people of African descent. (Courtesy of Ed and Josie Lambright.)

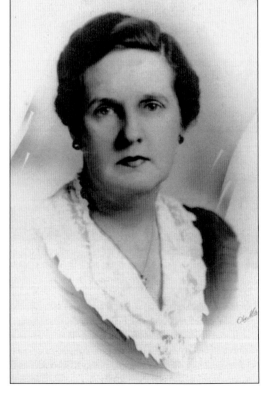

Gould Ford Motor Company, "the old Reliable," was a Brunswick institution, located at 1608–1612 Newcastle Street. Seen from left to right, James D. Gould III and Col. James D. Gould Jr. (1896–1975) shake hands before the younger Gould departed. He was leaving town for Detroit, Michigan, to attend a Ford Dealer's Sons School where he received training in dealership operations and learned about the family business. Gould Ford operated from 1919 until 1972. (Courtesy of James D. Gould III.)

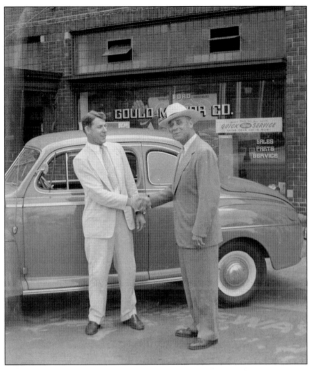

Louis Cedric Purdey (1902–1976) was a pied piper of Brunswick's commercial development through port growth. He steered post–World War II expansion as manager of the Brunswick Port Authority, with responsibility for public contacts through Chamber of Commerce operations. He managed the reconversion of former J.A. Jones Shipyard properties, securing tenants and industrializing the yard. During his two-year stint at the helm (1947 through the summer of 1949), Purdey aggressively promoted a "bright economic future" for the City by the Sea. The state's takeover of Jekyll Island in October 1947, road improvements, and proposed bridge construction projects suggested "an economic renaissance" to Purdey. After leaving Brunswick, he achieved recognition as an authority on Great Lakes and St. Lawrence Seaway maritime affairs. In Brunswick, Lou and Jeanne Renard Purdey performed in May 1948 for the Brunswick Community Concert Association at Memorial Auditorium. Their "Concert Grand Concert" featured his "golden voiced dramatic tenor" and her talents on piano and the violin, and both delighted the audience and contributed toward a growing "grand piano" fund. (Courtesy of Louis A. Purdey.)

Senior Superior Court Judge William R. "Billy" Killian poses in his robe, and his magisterial persona reflects Georgia's state motto, "Wisdom, Justice and Moderation." Appointed to the bench of the Brunswick Judicial Circuit on July 1, 1977 by Georgia Gov. George Busbee (1975–1983), Judge Killian observed much change while he actively served for 13 years. Today, the Judicial Circuit covers five counties—Jeff Davis, Appling, Wayne, Glynn, and Camden—and judges occupy nonpartisan positions. Through the years, an increase in the workload has necessitated the appointment of additional judgeships for a total of four. Two Senior Superior Court judges, Judge Killian and Judge Robert "Bob" Scoggin, can hold court anywhere within the state, including Glynn County, and four judges preside over the Brunswick Judicial Circuit. They are Blenn Taylor Jr., who retires by not seeking reelection in the fall of 2000; Judge E.M. Wilkes III from Jeff Davis County; Judge James R. Tuten Jr.; and Judge Amanda Williams. Prior to his appointment, Killian maintained a private law practice both during and after representing Glynn County between 1955 and 1964, serving five two-year terms as a Georgia State representative. During those years, fellow Glynn County legislative colleagues included Bernard Nightingale (1907–1981), the redoubtable Charles "Charlie" Gowen, Winebert D. Flexer II (1921–1985), and Joe Isenberg.

# Five

# PEOPLE AT WORK

*While living in Brunswick, poet Sidney Lanier wrote in an April 1875 letter, "I am convinced that God meant this land for people to rest in—not to work in. If we were so constituted that life could be an idyll, then this were the place of places for it . . ." (Tallu Fish, Sidney Lanier, America's Sweet Singer of Songs, 1963). Perhaps Lanier, the lover of verse would appreciate the diversity of men and women who appear across these pages. They and many others have contributed in both large and small ways to the fabric of life, its weft and woof, and the rich history of Brunswick, the City by the Sea.*

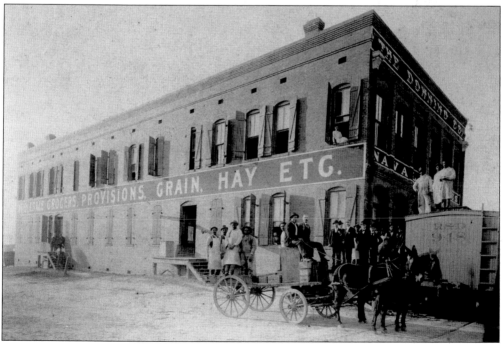

No one man put more men to work than Columbia Downing, a naval stores factor. Dating from 1882 when organized as Downing, Buck and Company to its evolution, in 1884, as C. Downing Jr. and Company, the Downing Company was incorporated by November 1890 and thrived for many years as a fixture on the Brunswick waterfront. It is seen here before a devastating 1896 fire. Writing in 1936, C.P. Dusenbury, a vice-president, estimated the company had handled 2 $^1/_2$ million barrels of Spirits of Turpentine and 8 $^1/_2$ million barrels of rosin—amounting to, when sold, a value exceeding $170 million. (Courtesy of C.S. Tait Sr. Photograph Collection and C.S. Tait Jr.)

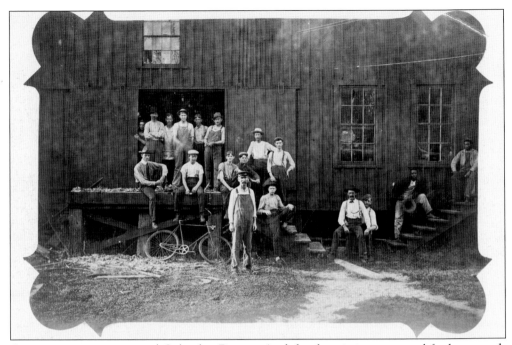

Great prosperity empowered Columbia Downing's philanthropic interests, and for hours each Christmas day, the Downing Company drays dispensed loads of hams, bacon, flour, crackers, delicacies, and other supplies to Brunswick's "worthy poor." So great was Downing's influence that upon his death in 1925, the Downing Memorial Association was formed, composed primarily of naval stores operators. After fundraising, an impressive monument was erected at Queen's Square in November 1926. Twenty-two feet in length, nine feet high, and five feet deep, the monument was made of the best grade granite of Mount Airy, North Carolina used by the McNeel Marble Company. The memorial stands today, near the Old City Hall. In this image, a group of unidentified Downing Company Fertilizer Factory men pause for the camera. (Courtesy of C.S. Tait Sr. Photograph Collection and C.S. Tait Jr.)

One of numerous burlap-sacked goods offered by the Downing Company, the "Brunswick Fish-Bone and Potash Guano" had passed through many hands before being shipped by sailing vessel or rail. From its gathering and manufacturing by unskilled workers to its loading by stevedores and shipping aboard seaworthy vessels, one 200-pound sack provided livelihood in a most fundamental "trickle down" way. C.S. Tait Sr.'s operation of the Downing Company wholesale groceries ran the gamut of commodities exchanged, sought after and sold from the farmer's production to the housewife's daily needs. (Courtesy of C.S. Tait Sr. Photograph Collection and C.S. Tait Jr.)

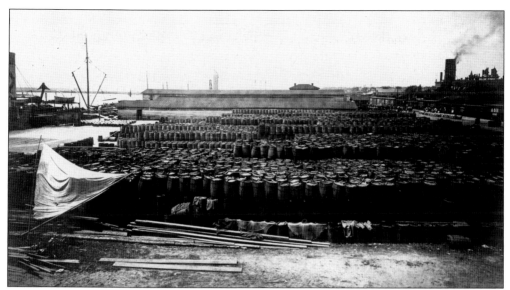

For as far as the eye can see, rosin barrels line the Downing Company Rosin yard, seen in this image with turrets of the Oglethorpe hotel (far right) and smoke stacks of the city waterworks and tower. In a 1902 report compiled and issued by William S. Irvine and the Board of Trade, the City by the Sea had experienced growth and development within a ten-year census period. In 1880, the population was 2,891 persons, and in 1900, 9,081 citizens. When compared with other south Atlantic ports, Brunswick stood first in the export of lumber, second in naval stores, third in cotton, and fifth in phosphates. (Courtesy of C.S. Tait Sr. Photograph Collection and C.S. Tait Jr.)

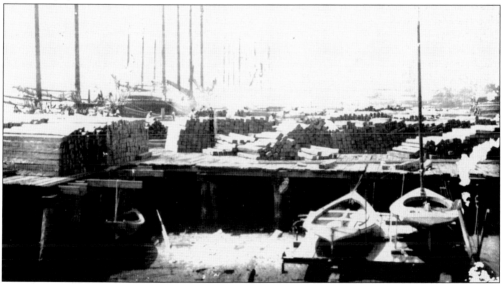

Within a ten-year period (1884–1894) Brunswick had benefited from the chartering of six banks and served as an important railroad and shipping point. This growth naturally led to the need for a Custom House, seen on page 38, and the cross-tie trade contributed substantially to shipments, in 1901, of 1,601,447 pieces. Look at the backlog of cross-ties awaiting shipment from the Downing Company's yard, seen in this image. These were the halcyon days. (Courtesy of C.S. Tait Sr. Photograph Collection and C.S. Tait Jr.)

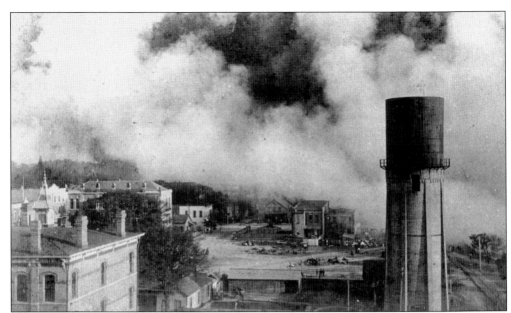

On April 2, 1896, an uncontrollable fire at the B&W Docks was attributed to sparks blown from a pile driver working on waterfront dockage. "Maddening flames fiercely roared," and the cotton piled high on the docks was quickly loaded onto the steamship *Humbert* averting its loss. Railroad cars were switched around, and only #259 loaded with railroad material was lost to flames. An honest and trustworthy employee, a watchman for B&W shops was overcome, and Charles Smith was the sole fatality. Heavy losers were the Plant System, the Ocean Hotel, and the Downing Company. (Courtesy of C.S. Tait Sr. Photograph Collection and C.S. Tait Jr.)

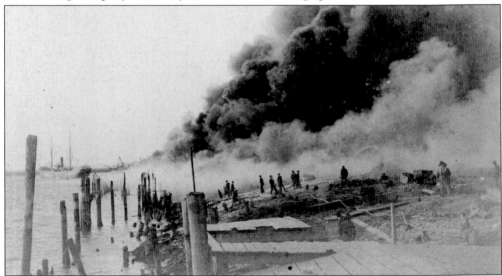

An editorial in the *Brunswick Call* acknowledged the "loyal firemen" and how but for their "manly labor the whole city would have been in ashes." Tug *Inca* was sent offshore, numerous small businesses suffered devastating losses, including the stores of Julius May, Briesnick's Machine Works, R.V. Douglas, T. Newman, and J.J. Lott and Company. Compounding matters was the loss of the entire Downing Company property, seen in the image—2,600 barrels of rosin going up in smoke. (Courtesy of C.S. Tait Sr. Photograph Collection and C.S. Tait Jr.)

A group of 85 delegates to the Sixth International Road Congress held in Washington, D.C., was routed down south by the Highway Education Board. Traveling by buses, the group's inspection of the Atlantic Coastal Highway was informative and they were entertained in high fashion by local dignitaries. Margaret Cate (front center) poses with the engineers at the Oglethorpe Hotel where they were honored with a sumptuous banquet and a short talk on local history by Cate. (Courtesy of Margaret Davis Cate Collection #997, Fort Frederica National Monument, Georgia Historical Society.)

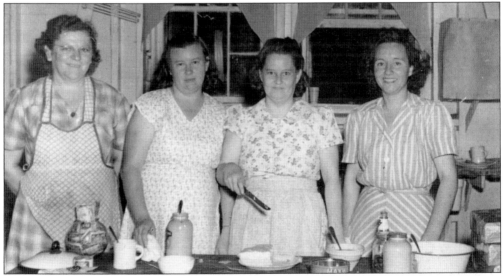

In a photograph from 1944 to 1945, ladies prepare food for the children of Purvis Elementary School at the Soup Kitchen. From left to right are Mrs. A.T. Harrison, Lois Newman, Frances Irving, and Georgia Elizabeth Wainwright Higginbotham. In 1933, Mrs. George W. Cowman served as chairman of the committee that represented the local chapter of the American Red Cross. When the Soup Kitchen originally opened, 200 of the school's enrollment of 280 young children benefited from a hot noon day meal. (Photo by Caples Studio; courtesy of Georgia Wainwright Murphy.)

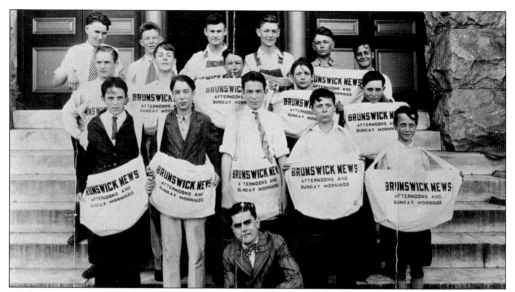

In these two images, glimpse fortunate young men and courageous women who held jobs during the Great Depression. The delivery boys for the *Brunswick News* pose on the steps of Old City Hall. Only two of the newsboys can be identified: (front row, far left) John "Jack" Davis and (second row, fourth from left) Burwell Liles. The unidentified supervisor stoops in front. Through a "New Deal" President Franklin Delano Roosevelt provided Works Project Administration employment opportunities. (Courtesy of Miriam Cate Manning Davis.)

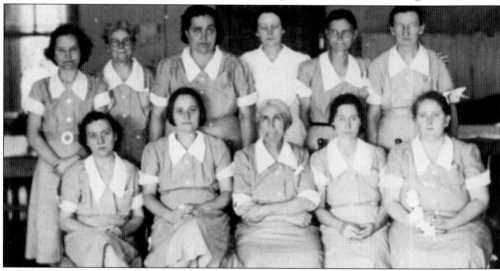

During the 1930s and 1940s, ladies employed through the Glynn County WPA Sewing Room worked a 40-hour week. Using pedal-type machines, they made quality clothing under government contract. Pictured seated third from left is ? Holmes and standing, from left to right, are unidentified, ? McCall, unidentified, Fannie Lee Brown Manning, Cassie Lord, and ? Harris. A gifted seamstress, Supervisor Fannie Lee Manning (1895–1982) was befriended by Margaret Cate and the McGarvey sisters who approached their friend Maude Lambright, director of the Glynn County Welfare Department, on Manning's behalf. Her resourceful, conscientious nature secured her a supervisory position through which, as a single mother of two young daughters, she supported her family. (Courtesy of Miriam Cate Manning Davis.)

Known as the workhorse of the port, the tug *Inca* lays up portside to a Liberty Ship being towed into the sound for a trial run. An unidentified mate smiles while a busy Capt. John Hotch turns his back to the camera. Responding to the war effort, the Brunswick Marine Construction Company contracted with the U.S. Maritime Commission to fabricate those "ugly ducklings" known as Liberty Ships. When their production schedule failed to meet expectations, a Charlotte, North Carolina firm, the J.A. Jones Construction Company, was hired as a replacement, and their presence was established on the waterfront by February 1, 1943. (Courtesy of Charles E. Ragland.)

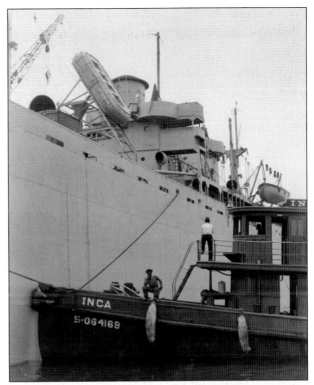

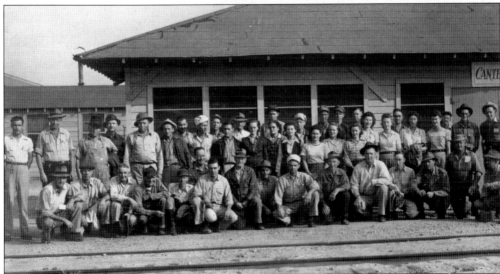

Shipyard days irretrievably changed both the complexion and character of Brunswick when a population boom hit, and at a high point, over 16,000 people were employed at the shipyard, about 2,000 of whom were women. Those were the days when "Rosie the Riveter" arrived on the Brunswick waterfront. War housing and new subdivisions sprung up to accommodate a work force running on three shifts, or a 24-hour-per-day schedule, for the production of "Ships for Victory," and after the war many of the rural folk remained. Here are the workers at the Electric Shop in 1943, J.A. Jones Construction Co., including Harry Nunn and J.C. Dubberly. (Courtesy of Charles E. Ragland and Old Town Brunswick Preservation Association.)

With Emil Kratt at the helm as general manager, the J.A. Jones Construction Company achieved numerous honors during its years of production on the Brunswick waterfront. On March 23, 1945, the company earned a "Gold Eagle" pennant for meritorious war time production and consistently emphasized the safety of its workforce. One of its highest honors was bestowed by the National Safety Council in 1944 for an extraordinary year and a "Service for Safety Award." On the homefront, civilian pilots and a Civil Air Patrol took off from a dirt strip at Redfern Field on St. Simons Island while strategically placed airplane spotters recorded unusual observations on logs. Coastal boaters joined the ranks of the Georgia State Guard in 1942 when a group of civilians familiar with coastal waters and the barrier islands assisted in the war effort. Government instituted rationing of scarce commodities and coastal blackouts while war bond drives encouraged nationalistic feelings. Brunswick girls met future husbands at chaperoned dances and other USO functions, soldiers drilled, and Glynn Countians responded to needs by planting victory gardens and doing home canning for the larder. (Courtesy of Jimmy Dedge.)

A HAPPY
NEW YEAR
TO ALL

THE
BRUNSWICK *Mariner*

PUBLISHED BY J.A. JONES CONSTRUCTION CO. INC. — FOR THE BUILDERS OF SHIPS FOR VICTORY

A PROSPEROUS
1945 PRODUCTION
YEAR

VOL. 3.     BRUNSWICK, GEORGIA, FRIDAY, DECEMBER 29, 1944.     NO. 50.

# CHRISTMAS WORK
## 1,500 MAN PRODUCTION GUNS

### Present 8th Pennant Star To Shipyard

As Brunswick shipbuilders poise on the eve of the exit of 1944, a banner year for them in ship production, they have received their eighth gold star for the coveted Maritime "M" pennant.

According to word received from the Maritime Commission the yard was awarded the additional star for completing another cycle of production. The award was received this week and the star has been added to the pennant flying on the flag pole in front of the administration building.

Along with winning another star, some good news was forthcoming this week with the announcement that manhours on the SS George W. Norris and the SS Arthur M. Hulbert went below the 500,000 figure, for the first time in the yard. No manhour figures have been released since the SS Hulbert was delivered.

### Bus Service Discontinues

Workers Transport buses, ten in number, will discontinue their routes after Saturday, December 30, 1944. The management of Workers Transport Bus Company received permission to cancel these trips after explaining that many shipyarders were moving into Brunswick and that the number who were riding the buses has declined to a point making the "runs" unprofitable and unnecessary.

The yard rationing office has announced that it is prepared to provide gasoline to car-sharing groups without any delay.

### Men Advised About Draft

B. W. Prassel, industrial relations director, explained that due to procedure just announced by Selective Service officials, it is requested that all men subject to Selective Service should contact Marie Kellow at the shipyard's Selective Service office. Personnel building, 15 days before the expiration date of their current deferment.

### Next One!

Brunswick's seventh Liberty ship launching of the month is slated for 10:00 o'clock Saturday night when the SS William Cox is launched from Way Three. The ship, named after a negro Merchant seaman, will be christened by the man's widow who will come here from Savannah for the ceremonies.

Reporting in strength of approximately 1,500, a corps of Brunswick shipbuilders closed in on the production front Christmas day with a series of effective jabs as they shared the forfeit of their holiday with the men and women of the armed forces and worked without pay in order that the yard's rapid-moving production program would not come to a complete shutdown. Workers on all three shifts shared in the movement.

#### Citation

Ralph B. Sessoms, swing shift welder inspector, was the recipient of a copy of this citation awarding the Bronze Star Medal to his son, Captain Ralph B. Sessoms, of the 80th Infantry Division, United States Army:

"A Bronze Star Medal is awarded to Capt. Ralph B. Sessoms, Jr., 025097, Infantry, United States Army, for meritorious service in France during the period 8-16 November, 1944, in connection with military operations against an enemy of the United States.

"During the period 8 November 1944 to 18 November 1944, Capt. Sessoms, as Regimental S-3, has carried out his duties with efficiency and tireless devotion to duty. On a number of occasions, he has analyzed the situation and made necessary decisions on his own initiative which contributed materially to the success of his regiment in attacks against the enemy."

The plan was instigated last Friday by a crew of 80 shipfitters along the ways. The welders followed suit and the riggers and crane operators declared they would not be outdone. When General Manager E. J. Kratt was quizzed as to the legality of the plan, he congratulated workers over the P. A. system, and shortly afterwards, countless numbers of offers poured in.

J. F. McInnis, in a statement to the Associated Press, commended the shipbuilders on their patriotic gesture and said they "could hardly be refused." Approval of the work schedule was made Friday night.

So far-flung was the feeling, it created national attention. John D. Tinnon, vice president of the Metal and Thermit Corp., Larchmond, N. Y., wired that his company would furnish without charge the arc welding electrodes

(Continued on page two)

### S. S. Jerman Slides Ahead Of Schedule

Scoring of the sixth launching in December came long before the whistle blew this month, in fact, at the beginning of the third quarter, when the SS William F. Jerman slid into Oglethorpe bay Saturday at 1:50 o'clock, five days ahead of schedule. Mrs. Charles W. Tillett, head of the women's division of the Democratic National Committee, Charlotte, N. C., christened the vessel. Co-sponsors were her two daughters, Mrs. William I. Coddington and Miss Sara A. Tillett.

Presenting the sponsor's bouquet was Miss Mary Osteen, tool room department, and star bus-cttes. Frank Poole, administrative assistant, acted as master of ceremonies, and the Rev. T. L. Harnsberger, First Presbyterian church minister, offered the invocation.

In a brief statement after the christening, Mrs. Tillett said that women are expected to play a considerable part in the world peace table. "Women have been making great headway in the field of politics," she said, " and have been delegates at the world conferences which will decide the policies of this country and those of its allied nations. There was a woman expert at the recent World Food conference and also one at the Monetary conference." Mrs. Tillett remarked that one state in the west has 12 women as members of its present legislature, and that there are more women men in our national congress than ever before.

The SS Jerman was named for the late master of the SS Cities Service Empire which was torpedoed in February 1942. Jerman was a native of Minneapolis, Minn.

Santa Claus W. A. Lindsey works on Hull 179 on Christmas Day.

Making demands on the six-way yards such as Brunswick's, the U.S. Maritime Commission encouraged the fabrication, production, and delivery of six Liberty Ships for December 1944. Talk in the shipyard grew to a boasting, challenging level, promises were made, and 80 shipfitters offered their Christmas Day work as a donation to the war effort. Others followed suit. Paychecks were signed over to the U.S. Treasury, and in an unprecedented act of camaraderie and unequalled performance, the J.A. Jones Construction Company delivered seven vessels, the last one on December 30th! Pride in a job well done was rewarded by free public transportation, and the operators of the shipyard cafeteria, Carley Zell and Albert Crews, donated free turkey dinners to the shipyard workers. Commentator Poke McHenry stated it best, "It was a magnificent, spontaneous outpouring of patriotism that drew raves of approval from servicemen all over the world." Brunswickians touched the lives of many people through this magnanimous gesture of donated work on the most revered day in the Christian world. (Courtesy of Jimmy Dedge.)

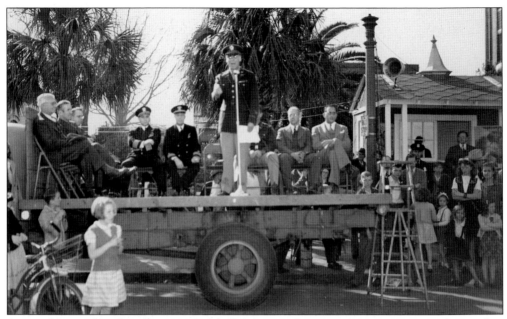

A crowd has gathered at downtown's Jekyll Square to hear stirring, patriotic speeches, and at the microphone, Col. James D. Gould Jr. admonished the gathering. Notice the corner of the Brunswick Bank and Trust (right), Brunswick's oldest bank, incorporated in 1889 and located at 1419 Newcastle Street. (Courtesy of James D. Gould III.)

Located at 1600 Newcastle Street, the Lafayette Grill was managed by Hy Strauss and Betty Strauss from the late 1930s through the 1940s. This "First Class Restaurant in the New York Manner" catered to locals and to tourists bound from the northeast to Miami. This card also noted the Grill's location as "situated 914 miles from New York and 428 miles north of Miami"—on the short route to Florida via Highway 17—putting Brunswick on the map. (Courtesy of E. Ralph Bufkin.)

"New Town"" offered a mixed residential and commercial setting where Mom-and-Pop-style corner groceries dominated a Norwich Street corridor. A memorable business dating from the late 1920s was Williamson's Store, which relocated on a couple of occasions and evolved by selling not only staple grocery items but newsy items at "Williamson's Newstand." In the image, Mabel Arnett Williamson (front left) poses in her store at 2119 ¹/₂ Norwich with, from left to right, ? Pierce and Courtland Arnett. (Courtesy of Jonell Williamson Coleman and family.)

Notice the sidewalk pavers in a typical mid-20th century Norwich Street scenario where Arnett kinsman have gathered. In the background, Williamson's Newstand can be seen. Basil Arnett (left) stands in the doorway of a family-oriented confectioners at 2115 Norwich, next to other unidentified members of the Arnett family from Mt. Pleasant, and businesswoman Mabel Arnett Williamson (second from right). (Courtesy of Jonell Williamson Coleman and family.)

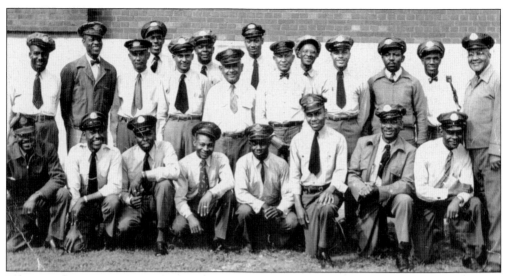

When mail service was originally inaugurated on April 1, 1890, Brunswick's post office was located in the Borchardt building on Grant Street, and Ellis Hunter served as postmaster. Five mail carriers of African-American descent were appointed, including Oliver M. Buggs, Henry Molding, George Abbott, W.H. Myers, and O.F. Pyles. In this later photograph, the number of Brunswick mail carriers has increased dramatically. Kneeling in the front, from left to right, are G. Dawson, A. Halse, B. Jaudon, unidentified, L. Green, J. Eppings, E.V. Wright, and P. Rhaney. In the back row, from left to right, are ? Nelson, H. Cuthbert, E. Council, L. Moore, E. Lewis, T.D. Pickens, J.P. Monroe, D. Lucas, J.P. Atkinson, C. Walters, H. Coleman, G. Baskin, H. Armstrong, and S.G. Dent. (Photo by Ragland Studio of Graphic Art; courtesy of Josie Atkinson Marrow.)

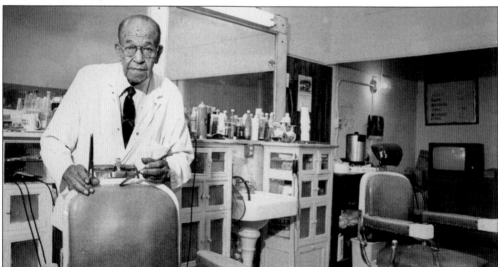

Hickory hardwood chairs, a photograph of the 1927 Glynn Academy football team, and a replica statue of the classic *Venus de Milo* in the window suggested a penchant for yesteryear and antiquity at Floyd's Barber Shop. Little did William Marion Floyd know when he opened his doors in 1893 that his business was destined as an institution for generations of Brunswickians. In 1928, Howard Eugene Battle (seen above in 1989) ultimately presided over downtown's premiere barbering emporium. (Courtesy of Bobby Haven/The *Brunswick News*.)

In this 1970s image Vincent Francisco Fernandes (1895–1975) steps out of his office at Dixie Sea Food, located at the foot of London and Prince Streets. In the mid-20th century, "Captain Frank" operated his packing house in competition with other area seafood businesses such as Union Shrimp Company, Lewis Crab Factory, King Shrimp Company, Jekyll Island Packing House, and Brunswick Shrimp Packers. (Courtesy of Henry Fernandes.)

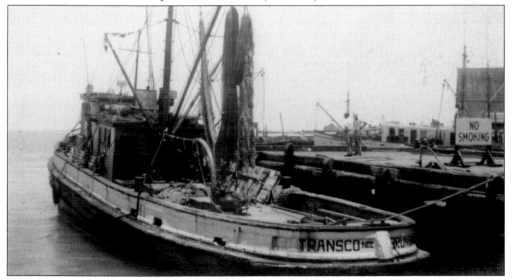

Fernandes was born in the Portuguese Madeira Islands off the coast of Africa, and he arrived in Glynn County sometime after 1916. On the waterfront, his shrimp trawlers were identified by locals as the *Salazar* and the *Restaurador*. In this image, see the *Transco*—a 67-foot wooden vessel used as a fire boat during World War II. Converted for shrimp trawling, the *Transco* plied Georgia and Florida waters from 1948 until the early 1970s when Fernandes sold it to a North Carolina shrimp fisherman. (Courtesy of Henry Fernandes.)

Ruby Wilson Berrie (1893–1983) began her life's work to promote commerce and the City by the Sea through the old Brunswick Board of Trade when she was only 21 years old. The organization was renamed the Chamber of Commerce in 1946, and Berry served successive office holders through the years as both secretary and office manager. One of her outstanding achievements was in preparing a prospectus book that, in the late 1950s, brought Twentieth-Century Fox, movie stars, and the filming of *The View from Pompey's Head* to Brunswick. At a November 1961 testimonial dinner held in honor of her retirement at the Cloister Hotel, Berrie was recognized for her excellence by local businessman Wiley A. O'Quinn Jr., chamber president (1952–1954). She had served 47 years with the Brunswick–Glynn County Chamber of Commerce (1914–1961) and was an early "Good Will Ambassadress" for Brunswick and the Golden Isles of Georgia. In this image, Berrie stands at the entrance to the 1930s information center at the F.J. Torras Causeway. Nearby is the 1850 bronze bell by John Benson, a relic of the antebellum era that formerly hung in the belfry of downtown's old marketplace and was useful for announcing the arrival of fresh meat and produce. (Courtesy of Ruby Wilson Berrie Collection and Bryan-Lang Historical Library.)

# Six

# CELEBRATIONS AND SPECIAL EVENTS

*Celebrations and special events color the historic past in the City by the Sea, and the following images suggest only a few memorable ones. Reunions, marching bands and reviewing stands, and eager children conjure a scenario. Dazzling theme-based floats with eye-catching, multicolored streamers suggest a Homecoming or state championship football team arriving at Lanier Field. Whether downtown or at Edo Miller Baseball Park enjoying a 1950s-era Georgia Florida Baseball League "Brunswick Pirates" game, crowds gathered for passive recreation and entertainment. On the Brunswick waterfront, regattas and Blessings of the Shrimp Fleet continue as honored traditions as well as those growing number of activities promoted through the Golden Isles Arts and Humanities Association.*

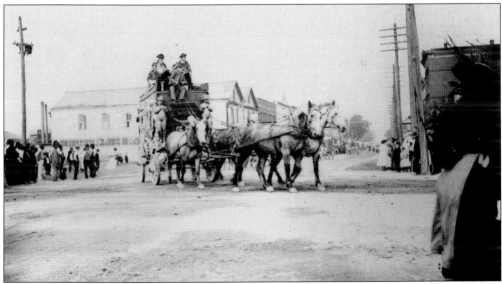

As a John Robinson Circus arrives downtown, c. 1898, crowds linger on a southbound Newcastle Street. In the background of the image, notice the old Bijou Theatre building and in the foreground look at an unusual tableau parade wagon. Featuring ornately carved statuary on its four corners, the wagon rounds the intersection of Newcastle and Mansfield Streets and is headed to the circus grounds once located at Union Street and Second Avenue. (Courtesy of C.S. Tait Sr. Photograph Collection and C.S. Tait Jr.)

Known as the main guy, John Robinson (1807–1888) organized his show around 1842, catering primarily to southern villages and small towns in the winter season. When the Robinsons sold out to Jerry Mugivan and Bert Bowers in March 1916, the Robinson name— "the old reliable, long-established, floating amusement concern with experience"—was worth a reputed $40,000. What came to Brunswick was "John Robinson's Ten Big Shows." In the image, notice the Brunswick Bank and Trust Building in the background as the Grand Parade makes its way slowly down the Newcastle corridor. (Courtesy of C.S. Tait Sr. Photograph Collection and C.S. Tait Jr.)

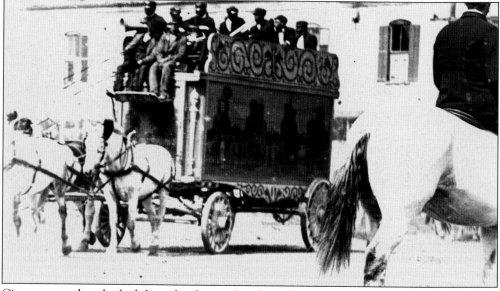

Circus-goers who plunked down hard-earned cash at the red ticket wagon gained admittance to viewing unique animal cages, those picturesque houses on wheels, and Robinson's became known as a "Cottage Cage Circus." Attending the "Ten Big Shows" meant taking in the aviary cage, a circus in each of three rings, the three big menageries, an allegorical float or grand Biblical spectacle, the gigantic museums, and the prodigious aquarium. (Courtesy of C.S. Tait Sr. Photograph Collection and C.S. Tait Jr.)

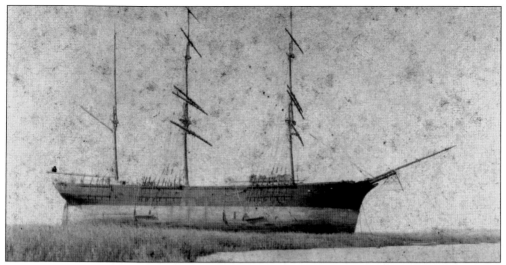

Weighing 621 tons, the *Louise* was blown "high and dry on the marsh by a Cyclone of October 2, 1898." Two items in the *Brunswick Call* dating from mid-October reveal additional information, including that the Stewart Contracting Company was hired to float the *Louise*. The steamer *Egmont* was blown 510 feet into the marsh and workers dug a canal 10 feet wide and 4 $\frac{1}{2}$ feet deep to float the *Egmont*. Captain U. Dart oversaw the work, and the men used the little steamer *Charlie Dart* to haul the *Egmont* into the river. Within seven days of the work's beginning and little damaged by the storm, the *Egmont* resumed her run to St. Simons. (Courtesy of Sara B. Ratcliffe and Bill Brown.)

A "tidal wave" swept over the barrier islands of southeast Georgia and the mainland on October 2, 1898. Members of the W. Robert Dart family air their linens after rising water deluged their home, 6 inches over the first floor window sills, and their cellar partially filled with silty marsh mud. Pictured from left to right are (standing) "Robbie" and her sister Janie; Lulia Dart Myers her husband, Joe H. Myers; and W. Robert Dart. In the window are sisters Ethel, age six, and Sadie. Presently, the Dart family's substantial wood frame home at 4 Glynn Avenue serves as the headquarters of the Chamber of Commerce and Brunswick-Golden Isles Visitors Bureau. (Courtesy of Sara B. Ratcliffe and Bill Brown.)

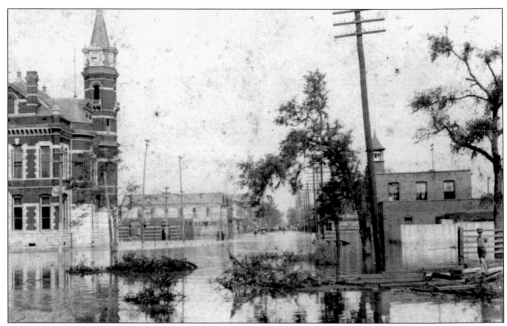

Some meteorologists predict through computer simulation and oral traditions that this big storm was a direct hit on Cumberland Island and funneled up the Saint Mary's River to its navigable headwaters at Trader's Hill, now in Charlton County, Georgia. One of three images shown and taken downtown by Charles Tait Sr., this picture captures the dire circumstances of standing water near the center of government at Old City Hall and the city fire protection offered by the Brunswick City Fire Department with the tower at the far right. (Courtesy of the C.S. Tait Sr. Photograph Collection and C.S. Tait Jr.)

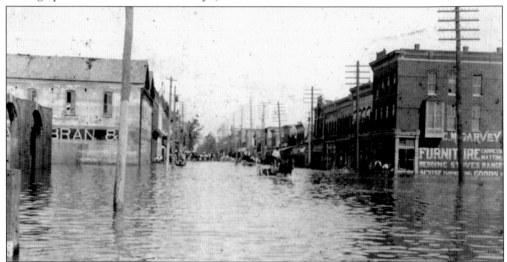

Looking north on Newcastle, the street is awash with tidal salt sea water. Oozing into the C. McGarvey Furniture business (front right), the water undoubtedly caused the proprietor to offer a "hurricane sale" of his fine furnishings to the Brunswickians upon whom his business success depended. With three stories, the McGarvey family had options for re-locating wares as the first floor at 1312 Newcastle flooded beyond redemption for fine veneered furnishings. (Courtesy of the C.S. Tait Sr. Photograph Collection and C.S. Tait Jr.)

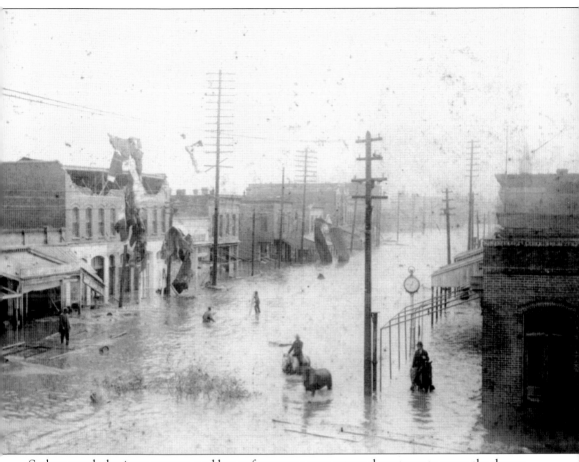

Stalwart souls, business owners, and law enforcement men return downtown to assess the degree of devastation wrought by a precedent-setting event. Were there weather signs? Look for those high veils of cirrus clouds, the rabos de gallo or "cock's tails" in the sky, as some predict, before a tumultuous outbreak of nature's hurricane fury. By mid-month a storm relief committee had formed in Brunswick under city guidance. On Saturday, October 15, 1898, a journalist for the *Brunswick Call* reported, "The people of Brunswick and Glynn County suffered very severely from the storm . . . All homes and business houses in the lower portion of the city were submerged to greater or less extent." Union Street was a flowing river and houses cracked and strained with the gusting hurricane-force winds. A loud surf echoed through the city, and silted marsh mud and the stench of decaying debris permeated the air. Looking south on Newcastle Street, the clock spire of Old City Hall can be seen, as can a freestanding streetside clock replicated today at the Ned Cash and Associates Jewelers, 1418 Newcastle Street. Rent awnings of the numerous businesses that lined a prosperous downtown suggest the wind damage that remained as the water receded. Men on horses wade through the salty water bilged up from Oglethorpe Bay and the Brunswick waterfront. (Courtesy of the C.S. Tait Sr. Photograph Collection and C.S. Tait Jr.)

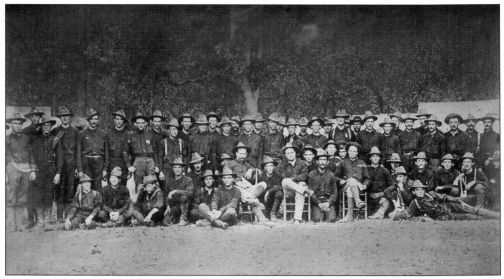

When Edward H. Mason (seen on page 60) served as the city mayor, a muster roll was taken of Company G, 1st Georgia Infantry, U.S. Volunteers, the old Brunswick Riflemen of Civil War fame. Commanded by Capt. R. Ernest Dart, those brave souls (seen above) numbered 91 men, and they were mustered from March 13th to October 1, 1898 in service to our country during the Spanish-American War. This rare photograph was salvaged by Company clerk, Pvt. Thaddeus M. Mroczkowski, wearing a tie in this historic photograph. (Courtesy of Stephen King Hart.)

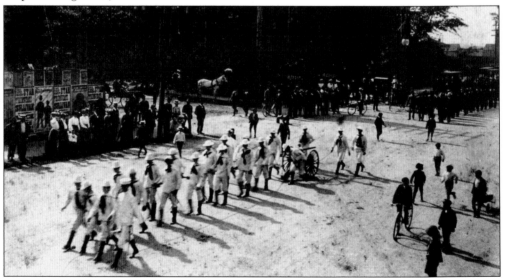

An act of the Georgia Legislature created the Naval Militia on December 19, 1893, and within one year, Company A of the Naval Reserve Artillery was organized at Brunswick. Commanded by Lt. Frank Aiken, the men who served from 1895 to 1908 drilled weekly and patrolled coastal tidal creeks and estuaries. Variously known as the Naval Reserve Artillery or the Naval Battalion, the Naval Militia enhanced its image by forming a Marine Band, the first in the South, headquartered at the unit's armory, 502 $^1/_2$ Gloucester Street. In this image, the Naval Militia parades on Newcastle Street during Confederate Memorial Day activities in April 1903. (Courtesy of Georgia Department of Archives and History.)

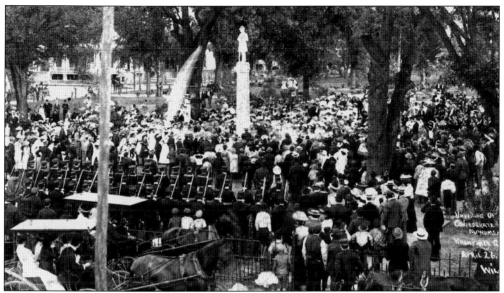

Through the vision of the Ladies Memorial Association and prominent Brunswickian Maria Morris Madden, a Confederate monument was unveiled on April 26, 1902, at Hanover Park. The association raised proceeds for the monument's creation and erection by sponsoring entertainment, annual dues, and one donation. The city council assisted with the laying of the foundation. An impressive 20 feet high, the monument was topped with a marble statue of a private. (Courtesy of the Houseman family and Old Town Brunswick Preservation Association.)

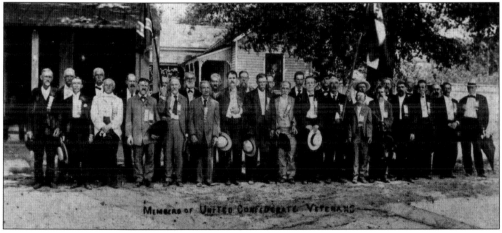

Organized on October 28, 1860, the Brunswick Riflemen were mustered into service on May 20, 1861. Reorganized as Company A, 26th Georgia Regiment, they served under Lawton, Gordon, Evans brigades, Army of Northern Virginia. This 1907 image was taken at Pennington's Photo Shop in Fernandina Beach, Florida. Thirty-one Confederate veterans, including some of the old Riflemen, from Camps Jackson and Nassau gathered. Seen from left to right are H. Dart, C. Doerflinger, L. Marlin, J. Morton, L. Leavy, three unidentified, ? Murray, A. Burney, I. Cohen, unidentified, T.F. Winter, Dr. W. Burroughs, two unidentified, N. Bell, unidentified, I. Davis, J. Dart, W.F. Doerflinger with the Flag, ? Elledge, two unidentified, J.T. Lambright, R.K. Boyt, B.F. Fahm, H.J. Read, R.H. Winston, T. Lamb, and unidentified. (Courtesy of Margaret Davis Cate Collection #997, Fort Frederica National Monument, Georgia Historical Society.)

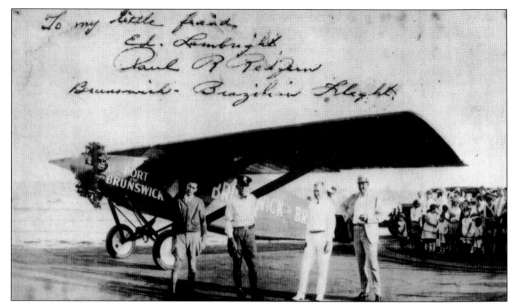

Signed to a young boy, Ed Lambright, by aviator Paul Redfern shortly before departing on his ill-fated 4,600-mile flight from Brunswick to Brazil, this image records a history-making event. Redfern's flight was sponsored by Brunswickians and automobile magnate Howard E. Coffin for what was envisioned as a "world record long distance non stop solo flight." Departing from the beach at Sea Island on August 25, 1927, Redfern's "Port of Brunswick" single-engine Stinson-Detroiter monoplane powered by a 200-horsepower engine was last seen by a Norwegian freighter off the Orinoco delta. What happened to Paul Redfern remains one of history's mysteries. (Courtesy of Ed Lambright.)

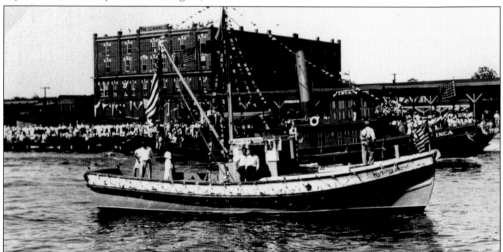

A 1934 May Day regatta on the Brunswick waterfront shows a festively decorated shrimp trawler, *Maria Fernanda*, owned by Capt. Manual Serra. Notice the workhorse of the port, the tug *Inca*, against a backdrop of the multistoried Downing Company Building, later home for Whittle's Furniture Company before its demolition. Other shrimp trawlers participating in the regatta included the *Joe M. Santos*, *Morning Star*, *Two Pauls*, *Three Girls*, and the *Vasco da Gama*, named after the 16th-century admiral of the Indies and navigator who discovered the sea route to India by rounding the Cape of Good Hope. (Courtesy of Mary Serra Santos.)

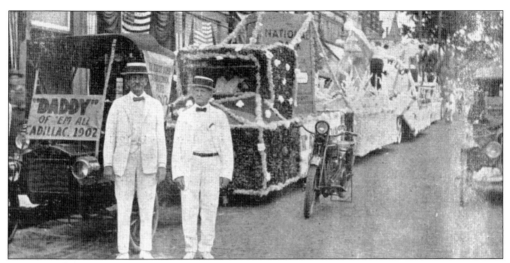

Leading the parade from downtown Brunswick, which celebrated the opening of the Brunswick–St. Simons Causeway on July 11, 1924, are William Foster Parker (left), president of Coney and Parker Company, and his friend Nathan Emanuel (1854–1939), standing by Parker's 1902 Cadillac, seen on page 64. Renamed in 1953, the F.J. Torras Causeway honored the engineer (seen on page 58) who achieved the impossible, performing a remarkable feat by spanning the salt sea marshes of Glynn to a remote St. Simons Island. On August 20, 1986, the F.J. Torras Causeway was rededicated to commemorate its four-laning and a new era of future growth. (Courtesy of Polly Parker Kitchens.)

Clothed in imperial dress, a stunningly beautiful Marjorie Troup Nightingale (1904–1990)—a "Georgia Peach"— appeared in a staged pageant as King George II's wife, Queen Caroline of Brandenburg-Anspach, and in the *New York Times* of July 24, 1924. Presiding over the exercises associated with the dedication of a St. Simons–Brunswick Causeway was a demanding occasion for a 20-year-old. Nightingale was born in the home of her grandparents, Columbia and Mary Downing, at 825 Halifax Square. After attending the famous Lucy Cobb Institute in Athens, Georgia, she graduated from Saint Mary's Hall in Burlington, New Jersey, in 1921. A violinist and one-time employee of Bergdorf Goodman's in New York, she married a West Point graduate in 1932, the future Maj. Gen. W. Hasbrouck. An ardent Episcopalian, she was active in social and charitable affairs in Washington, D.C., where the Hasbroucks lived. (Courtesy of Robert W. Hasbrouck Jr.)

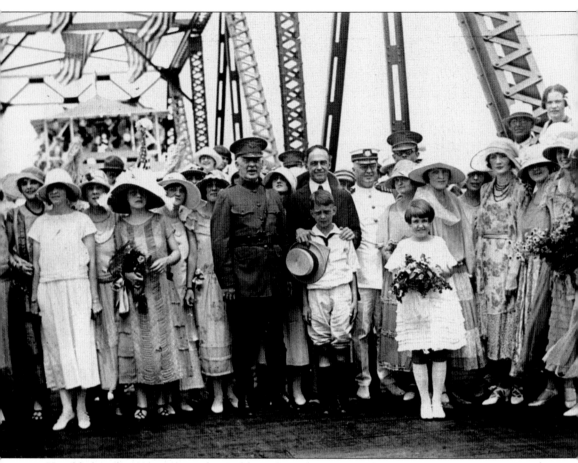

Heralded as the "Gateway to the Golden Isles," the Brunswick–St. Simons Causeway opened with great fanfare on July 11, 1924. Over 25,000 invitations were mailed out, the city was decked in flags and bunting, and a parade led from Gloucester at Newcastle to a shelled Lanier Boulevard, onto the Dixie Highway and the causeway's entrance. After crossing the Frederica River Bridge, city mayor Malcolm McKinnon's eight-year-old daughter Katherine (front row) assisted Georgia Gov. Clifford M. Walker with cutting the ribbon crossing the road. Greeted by island residents, Miss Felicite Gould presented the governor with the key to unlock the gateway. Afterwards, a 12-episode pageant was held under the live oaks at Gascoigne Bluff. Fifteen sponsors were selected "without apology, for their social prominence, gentle birth and manners," and these young ladies, such as Marjorie Troup Nightingale and Cornelia Leavy, appeared in banner headlines. Appearing in this festive crowd are Marjorie Troup Nightingale, Polly Wood, Elvera Torras, Mary Parker, Daisy Emanuel, Gov. Clifford M. Walker and his son Malcolm McKinnon, Dorothy Stevens, Florence Maxey, Selma Fendig, Florence Aiken, Frances Postell (Burns), Anne Stevens (Parker), and Mr. ? Shelander. (Courtesy of CGHS.)

Amidst great fanfare and accompanied by Dorothy Torras (left) and Mona Douglas (right), Mrs. Alfred Jones Sr. (center) christens the 24th Liberty Ship, the SS *Howard E. Coffin*. It was launched on January 21, 1944. After both dock and sea trials, the vessel was delivered on January 31, 1944, and within a few days went into the service of the South Atlantic Steamship Company. (Courtesy of CGHS.)

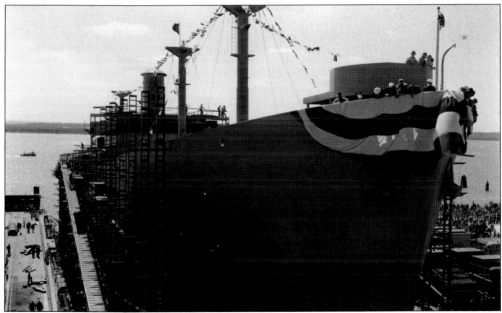

Bedecked in red, white, and blue bunting, the Liberty Ship's launching into Oglethorpe Bay and the South Brunswick River is imminent, as a crowd (seen at right) has gathered to watch. From a first launching of the SS *James M. Wayne* on March 13, 1943, thousands of eager spectators thronged into the City by the Sea to glimpse the launchings. (Courtesy of Charles E. Ragland.)

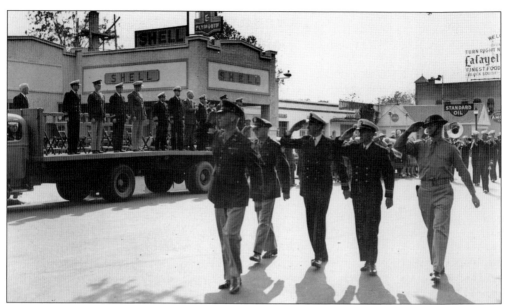

On October 27, 1943, a patriotic Navy Day Parade with marshall and staff being reviewed passes by Brunswick's City Hall. From left to right are Maj. James D. Gould Jr. and Captain J.N. McGee, Army Combat Unit; Lt. B.B. Bales and Lt. R.L. Jacobs, of Naval Air Station Glynco, Georgia; and 1st Lieutenant A.R. Fain, Georgia State Guard. Notice the landmark bank in right rear and signboard advertising the old Lafayette Grill. (Photo by U.S. Bureau of Aeronautics; courtesy of James D. Gould III.)

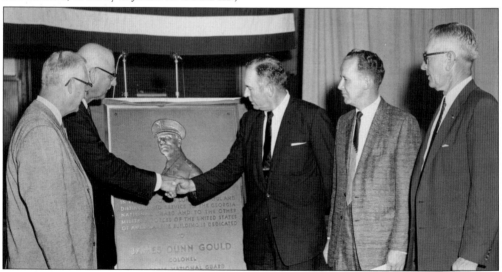

Serving as an infantry lieutenant in World War I, James D. Gould Jr. commanded a Georgia State Guard coastal battalion during World War II and was honored with designation as a full colonel. He served as a state senator for two-year terms in 1945, 1951, and 1957, was elected to four-year County Commission terms in 1952 and 1955, and served on the State Democratic Executive Committee. In this 1958 image, from left to right, are Frank Crandall, Colonel Gould shaking hands with Gov. Marvin Griffin, Russell Tuten, and Freeman Darby, Chamber of Commerce director. The men are pictured at the Gould Armory, 3100 Norwich Street, which was dedicated in his honor. (Photo by Gil Tharp; courtesy of James D. Gould III.)

In June 1956, the Little Theatre of Brunswick was tasked with putting together a pageant for August 1956 to commemorate the chartering of the city in 1856. Taken from the lines of Sidney Lanier, a ten-episode play titled *By So Many Roots* was written in a matter of weeks by Margaret and Mary McGarvey and presented on August 15 through 17, 1956, at Lanier Field. With backing from the Brunswick–Glynn County Centennial Celebration committee, chaired by Mayor W.H. Sigman, a fine official program booklet acknowledged contributors "without whom the program could have never gotten off the ground." (Courtesy of Margaret Davis Cate Collection #997, Fort Frederica National Monument, Georgia Historical Society.)

Performers enter a stage setting of *By So Many Roots* held at Lanier Field. Only guitarist Smitty "Shorty" Feimster is missing in the image, as the other three members of the Wonderful Washboard Band are pictured. From left to right are Nathan Jones on washboard and kazoo, Robert "Washboard" Ivory on guitar, and Nathan's son Charles Ernest Jones on a big bass fiddle. Originated in 1929 by Brunswickian Nathan Jones (1910–1968) and billed as "The Wonderful Washboard Band," the musical group entertained in area clubs, at Sapelo Island for R.J. Reynolds, at the Cloister Hotel, and in New York City. They appeared on the Garry Moore Show on April 28, 1959, as a follow-up promotional opportunity for their first album, *Scrubbin' and Pickin'*, recorded in 1958. (Courtesy of Donny Thompson.)

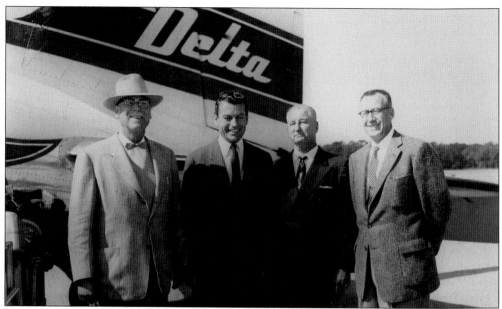

One of the most celebrated events in Brunswick's history occurred when movie stars Richard Egan and Dana Wynter arrived in 1955 to film *The View from Pompey's Head*. It was based upon a novel published in October 1954 that appeared on the *New York Times* bestseller list for 40 weeks. From left to right, Col. James D. Gould Jr., Richard Egan, and local dignitaries Fred C. Wilson of Georgia Power Company and the Brunswick–Glynn County Chamber of Commerce, and Brunswick mayor Millard A. Copeland pose at McKinnon Airport on St. Simons Island. (Courtesy of James D. Gould III and Clara Marie Gould.)

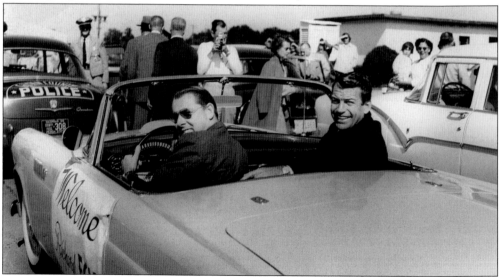

*Pompey's Head* was written by a member of the 1930s Southern Renaissance whose genius has recently been a focus of renewed interest. In his popular book, Hamilton Basso's theme played on the "return of the native" and the conflicts a Southerner confronts when he leaves and later returns home. A handsome twosome escorted by the Glynn County Police, Jimmy Gould III (left) and Richard Egan ride in Gould's 1955 red T-Bird. (Courtesy of Ruby Wilson Berrie Collection and Bryan-Lang Historical Library.)

Headquartered at the King and Prince Hotel, the film's director, producer, and script writer, Philip Dunne, was accommodated by Miss Margaret McGarvey as stenographer. Pictured is a street scene in *Pompey's Head* with actress Dana Wynter behind the wheel of Jimmy Gould's T-Bird, and in the background, a whimsical, sandcastle-style turret at the old Oglethorpe Hotel. The demolition of the hotel within two years of the film's wrap remains a wrenching loss to Brunswickians. (Courtesy of James D. Gould III.)

As Wynter wheels the T-Bird around Newcastle, Egan covers his face due to a "near wreck" and the actress's unfamiliarity with a powerful T-Bird. Brunswick was atwitter, Egan's charisma hypnotic, and locals clamored to be hired as part of the 40 extras needed for filming an Oglethorpe scene. Some of the locals who appeared included Mayor Copeland; his wife, Claire; their two lovely daughters, Jimmie Claire and Willou; Clara Marie Gould; Cornelia Leavy; Mrs. Sig Kaufman; and Kitty Hightower as Dana Wynter's stand-in. Notice on the sidewalk, locals May Jo Lott Bunkley (second from left) and Bruce Faircloth (far right). (Courtesy of James D. Gould III.)

A new Star rises over the Golden Isles of Georgia

Richard Egan plays the leading role in

"The VIEW FROM POMPEY'S HEAD"

Egan's photograph was signed to Mrs. (Ruby) Berrie, who, representing the Board of Trade, was in charge of local arrangements for filming, both in Brunswick and on a remote Jekyll Island. Egan's flashing smile caught the attention of young and old alike when, as a Hollywood movie star, he brought such excitement to Brunswick and the Golden Isles. Winner of a 1954 Golden Globe Award, his career was a promising one based upon a professional background as a Shakespearean actor, and he was a likely successor to Clark Gable. (Courtesy of Ruby Wilson Berrie Collection and Bryan-Lang Historical Library.)

Fred C. Wilson presided over a luncheon honoring Richard Egan at the Oglethorpe Hotel on November 4, 1955, with Rev. C. Douglas Jackson of Brunswick's First Baptist Church giving the invocation. Mayor Millard A. Copeland introduced guests, and Col. James D. Gould Jr. introduced our favorite star, Richard Egan. An interesting menu featured Oglethorpe Salad Bowl a la Philip Dunne, Golden Isles Barbecued Chicken with Pompey Dressing, Jekyll Island Asparagus Tips and Sauce Rambeau, Mulberry Plantation Yams, Hot Rolls Ritz, Egan Ambrosia, Dana Delights, and Coffee Blackmere. The occasion proved an unforgettable, banner day! (Courtesy of Ruby Wilson Berrie Collection and Bryan-Lang Historical Library.)

Oglethorpe Hotel – Brunswick, Georgia

CELEBRATING
the
Joint WORLD PREMIERE
of
"The VIEW FROM POMPEY'S HEAD"
November 4, 1955
Brunswick, Georgia

# Seven

# EDUCATION

*The education of Brunswick's youth has received top priority since 1788 and the sale of Town Commons land for Academy support. While in rural settings plantation owners often shared the services of a tutor, freedmen and women moved to the city for educational opportunities not offered in insular circumstances. Life was neither fair nor equal. Stellar educators whose stars remain bright in our memories include Viola Burroughs, J.S. Wilkerson, Sarah Molette, Beulah Lott, Bernice Tracy, and Miss Jane Macon. Hallowed halls remain objects of affection for graduates who have formed alumnae groups and actively participate in restoration projects and support preservation initiatives that enrich the community and our lives.*

Pictured on the left in the above image is Margaret Davis (Cate) who embarked on a long career and association with the education of Glynn County youth, both as a teacher and later as a member of the Glynn County Board of Education. Although no one-room schoolhouse exists today, here is one of wood-frame construction, topped with a wood shingle shed roof, and likely containing a woodburning stove for winter heating. Identified as the "Fourth Mile Crossing Schoolhouse," or the original Ballard area school, here the children were taught the basics—reading, writing, and arithmetic—in a no-nonsense fashion, and teachers inculcated traditional values associated with hearth and home and the family. (Courtesy of CGHS.)

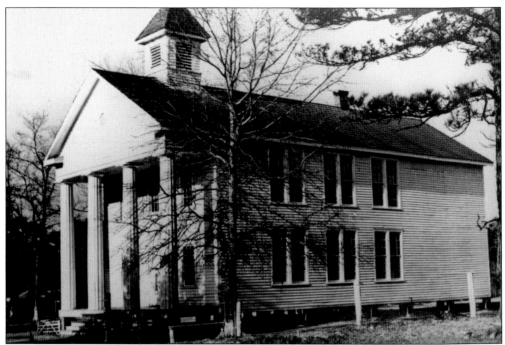

Mayor A.L. King conveyed Hillsboro Square to the trustees of Glynn County Academy in 1838 and proceeds from the city's sale of "New Town" provided for the construction of the Old Glynn Academy building. Built by Jonathan Bills of Connecticut and completed in 1840, the two-story Greek Revival wooden-frame building with four fluted Doric columns featured hand-hewn floor sills and was constructed of spruce pine. In 1915, this building was moved from the city to the rural Sterling community. The Old Glynn Academy structure is the only remaining antebellum building standing in Glynn County. (Courtesy of Richard and Gini Steele.)

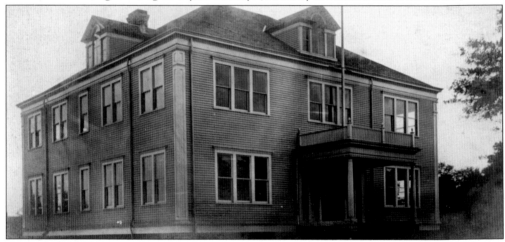

In 1902 the Glynn County Board of Education voted to build a new elementary school in "New Town." Completed in summer 1904, Purvis Elementary School honored George Purvis, a Revolutionary soldier and Glynn County surveyor. Purvis School was a wood-frame structure with an interior finished with high-quality long leaf pine. The school featured seven classrooms with basic equipment, a large room for vocational work, a home economics course, a teacher's room, and library. (Courtesy of C.S. Tait Sr. Photographic Collection and C.S. Tait Jr.)

In this 1916 image, Araneta Odham Tucker (1892–1978) poses with her fellow teachers, Misses Cochran (center) and Miss Robertson (right), when she had just begun a 40-year teaching career in Glynn County schools. Daughter of North Carolinians L.D. and Marietta Parker Odham, Tucker's father moved his family to south Georgia where he owned several sawmills and commissaries in Wayne, Brantley, and Camden Counties and served for a time as assistant police chief in Brunswick. Araneta graduated from Glynn Academy in 1910 with honors, attended normal school in Athens graduating magna cum laude, and received a masters of arts degree in education from Columbia University in New York. In 1939, she was appointed principal of Purvis School where she served until her retirement in 1956. (Courtesy of Gwen Chance Hickox.)

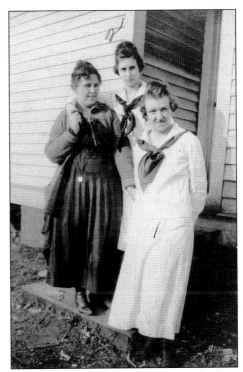

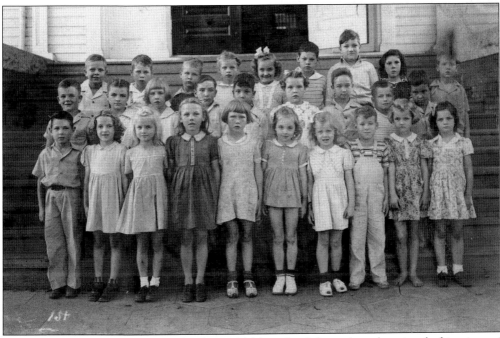

First grade students at Purvis School in 1946 benefited from the educational objectives of their principal, Araneta Odham Tucker, a stern disciplinarian and dedicated educator. Linda Higginbotham (Rape) (front row, fifth from right) stands with her classmates. Her mother, Georgia, was seen on page 81 in an image associated with Purvis School. (Courtesy of Georgia Wainwright Murphy.)

ANNUAL CATALOGUE AND CIRCULAR

——OF——

# Selden Normal & Industrial Institute

## 1911-12

FOUNDED OCTOBER 6, 1903.
INCORPORATED DECEMBER 1908.

*Brunswick, Ga.*

Founded on October 6, 1903 by Miss Carrie E. Bemus, a native of Ripley Crossing, New York, the Selden Normal and Industrial Institute was formally incorporated in December 1908. A board of trustees and an advisory board administered funding provided through the philanthropy of the Selden brothers. The institute offered educational opportunities and training in practical vocational trades for African-American youths until merging in 1933 with the Gillespie-Selden Institute in Cordele, Georgia. Principal H.A. Bleach admonished in this annual catalogue and circular, "Carve not the memory of your name on wood or stone, but carve it where it will live eternally, in the hearts of the young." (Courtesy of Josie Atkinson Marrow.)

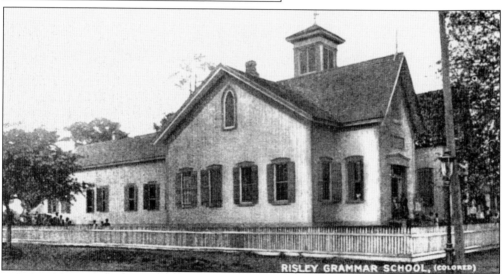

RISLEY GRAMMAR SCHOOL, (COLORED)

Dating from 1868, the original Risley Grammar School was located in the heart of a bustling mixed residential and commercial section of "New Town." It was named after Douglas Gilbert Risley (1838–1882), who arrived in 1866 with the Bureau of Refugees, Freedman and Abandoned Lands. The old Risley High School evolved from this public grammar school, the first for African Americans in Glynn County, deeded to the Glynn County Board of Education in October 1900. The Risley Alumni Association was incorporated in July 1992 as a nonprofit organization. Offering academic scholarships for qualifying youths will assure the fulfillment of the organization's mission for perpetuating "Risley High School as an integral part of the history and development of Glynn County." (Courtesy of Richard and Gini Steele.)

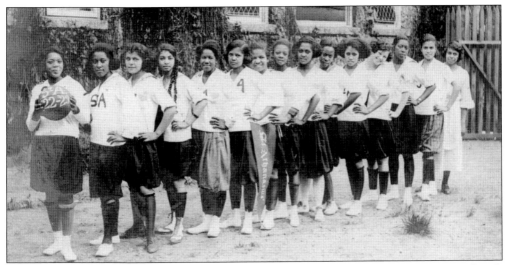

Another private, church-sponsored school affiliated with the historic St. Athanasius Church offered educational opportunities to children from affluent backgrounds. One of St. Athanasius' graduates, Dr. Cornelius V. Troup (Class of 1920) remembered the principal, William Augustine Perry, in his book *Distinguished Negro Georgians*. Also noted in the book were the high achievements of other locals, such as Dr. Nolan Atkinson, Henry J.C. Bowden, Charles Wesley Buggs, Anne Scarlett Cochran, and W.H. Dennis Jr., all graduates of St. Athanasius. In the image, 15 unidentified young ladies from the Class of 1922–1923 pose in a Reynolds school photograph near the old tabby church, located at the corner of Monck and Albany Streets. (Courtesy of Peggy Sullivan Hart.)

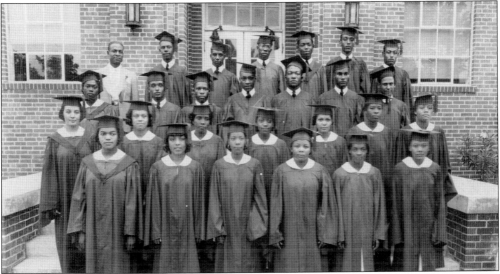

Twenty-six students pose for a Risley High School Class of 1939 photograph. Classmates included, from left to right, (front row) E. Cobb, S. Heidt, L. Anderson, unidentified, M. Mungin, and M. Signal; (second row) M. Caston, M. Armstrong, C. Lee, unidentified, H. Lewis, C. Reynolds, and P. Rhodes (Appling); (third row) C. Barnes, H. Smith, E. Brogsdale (later the Reverend E. Brogsdale), W. Holmes, ? Jones, unidentified, and E. Lewis; (fourth row) renowned educator and principal from 1928 until 1939 Professor C.V. Troup, O. Cobb, H. Smith, J. Hall, R. Kitchens, C. Gibson, and H. Jackson. (Courtesy of Creola Barnes Belton.)

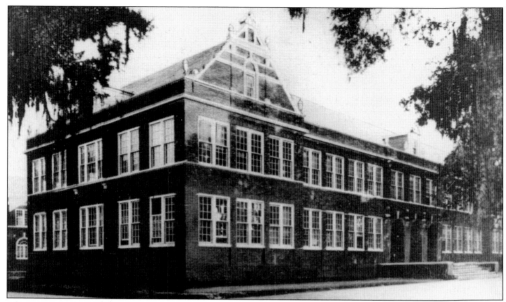

Dating from February 1, 1788, Glynn Academy is the second oldest high school in the state. Designed by Savannah architect Henrik Wallin and constructed by Georgia's West Point Iron Works, the Glynn Academy Building was dedicated on Armistice Day, November 12, 1923. Known as Memorial Hall, this impressive building stands as a tribute to the local veterans of World War I. An oversized marble plaque recording the names of those who lost their lives was erected by the Brunswick chapter of the DAR and placed at the top of the stairs above Memorial Auditorium on Armistice Day, 1924. In 1999, a newly remodeled Memorial Hall received an outstanding achievement award from the Georgia Trust for Historic Preservation. (Courtesy of Richard and Gini Steele.)

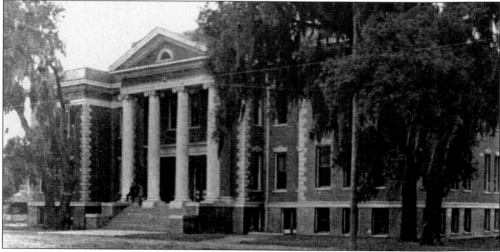

Designed by architect Alfred S. Eichberg, Old Prep High School (c. 1889) was renamed the Glynn Academy Annex in 1936. In September 1889, a period newspaper, the *Brunswick Daily Advertiser*, commented on the "very dignified and imposing appearance" of this structure, one of two standing public buildings in Brunswick designed by Eichberg. Eichberg's genius used natural lighting to advantage from two sides for each classroom and an exterior trimmed with stone. (Courtesy of Richard and Gini Steele.)

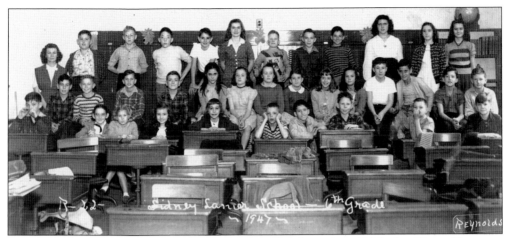

Rural consolidation brought children into city schools, and in 1936, the Glynn Grammar School moved to a new building and was renamed the Sidney Lanier School. Within ten years, eager students in Miss Norma Mathis's sixth grade class pose for a Reynolds 1947 class photograph. From left to right are (front row) B. Paulk, M. Richardson, B. Sammons, P. Parker, J. Patha, B. Peerson, C. Strickland, E. Tiller, N. Spell, and B. Spell; (middle row) L. ?, B. Patrick, D. Sumner, D. Riner, B. Lee, S. Slade, J. Nichols, L. Taylor, M. ?, L. ?, C. Strickland, F. Taylor, R. Turner, and S. Russell; (back row) Miss Norma Mathis, W. Tait, N. Reu, B. Zell, C. Smith, R. Clark, J. Taylor, R. ?, J. Shierling, A. Settles, J. Phinazee, and E. ?. (Courtesy of Polly Parker Kitchens.)

Built in a setting of great live oaks, the Glynn Academy campus inspired a sense of history and appreciation for the natural world. In this image, Tait's Auto Service loaned a GMC truck for a homecoming parade—a reminder of the fierce competitiveness of Brunswick's athletes. Among others, those who excelled in golf included Mary Stevenson Melnyk, Steve Melnyk, Bill Ploeger, and Davis Love III. Jimmy Bankston excelled in swimming, Tiger Flowers in boxing, and Charles "Greek" George and Sam Bowen in baseball. Football stars include Vassa Cate, Bob Sherman, Hilman Rhodes, Lamar "Racehorse" Davis, Chandos Highsmith, and George Rose, as well as the successful career (1944–1961) of Glynn Academy Red Terrors football Coach C.M. Page, racking up 161 wins, 69 losses, and 10 ties.(Courtesy of C.S. Tait Jr.)

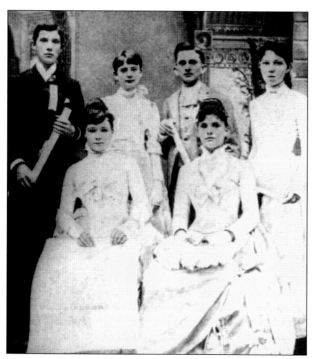

A photo of Glynn Academy's dignified graduating class of 1888 includes, from left to right, (front row) Lula Hay and Daisy Keen; (back row) Willis Dart, Mina Pottle, Daniel Krause (later an attorney and judge), and Nellie Emery. In 1966, the Glynn County Board of Education built another secondary school, Brunswick High, which maintains a high level of rivalry in academic and athletic competition with students from the venerable Glynn Academy. (Courtesy of Richard and Gini Steele.)

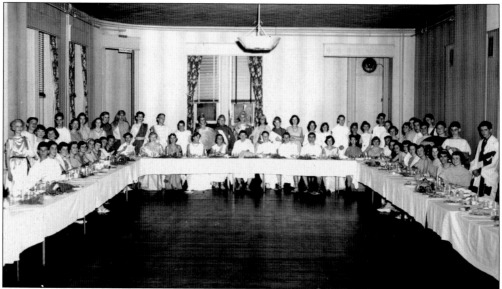

Standing front left, the legendary educator Miss Lula Howard (1902–1979) orchestrated Roman Banquets and Saturnalias for her students and members of the Junior Classical League. They are seen here in the 1950–1951 revelry at the old Oglethorpe Hotel. The group was one of the largest clubs at Glynn Academy, with eligibility extended to all Latin students. Howard inspired generations of students who awarded her a surprise trip to Rome in 1964 as the festivities of the Roman Banquet concluded. Howard was a charter member of the Pilot Club of Brunswick, dating from 1946. Since 1979, the club annually awards a "Lula Howard Memorial" Silver Bowl to the member who contributes the most service to this community service organization. (Courtesy of Polly Parker Kitchens.)

# *Eight*

# SOCIAL, RELIGIOUS, AND CULTURAL LIFE

*More than 100 houses of worship representing 27 denominations dot the landscape of Brunswick–Glynn County, providing ministry within the faith community and through benevolence groups to the community at large. Only a few of these denominations have been represented through images. Glimpse historic social organizations and cultural activities that grow with an increasing urbanizing population where once a sleepy port city languished. Active restoration projects at the Old Opera House, Glynn County Courthouse, Old City Hall, and New City Hall demonstrate a county-wide commitment to preserving historic seats of government, and a center for the performing arts in the City by the Sea.*

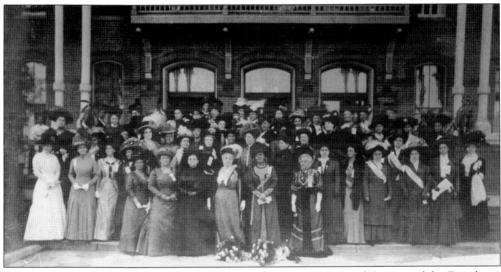

Twelve charter members organized the Brunswick chapter, National Society of the Daughters of the American Revolution on "Georgia Day," February 12, 1903, making the active chapter one of the oldest in the state. Within a few short years, local and state members attended the Georgia State DAR Conference held in 1909 amidst great pomp and circumstance at the well-appointed Oglethorpe Hotel—the ladies celebrated and wore finery befitting the occasion. State regent of the Georgia Society, NSDAR, Anna Caroline Benning (front center) was the daughter of Confederate Gen. Henry J. Benning for whom Fort Benning in Columbus, Georgia, was named. (Courtesy of Richard and Gini Steele.)

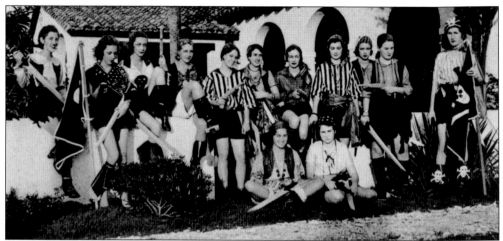

Organized by Howard Coffin, the "Pirate Gang" played on a theme of ransom and booty, recalling those historic days when the "Pirates of the Spanish Main" frequented coastal waters. Targeting visitors in the Golden Isles, Pirate "raiding" parties charmed their captives, promoted Brunswick and the Golden Isles, and the young ladies from prominent families passed along legacies for limited membership in the high school sorority. Through the years, the constitution of the "Pirates of the Spanish Main" has been amended to admit from 35 to more than 50 young women who work on behalf of this service organization. This image was captured at the Brunswick-Golden Isles Tourist Center on Glynn Avenue in September 1931. Charter members shown, from left to right, are (seated) B. Egbert and L. Harper; (standing) W. Cunningham, J. Macpherson, B. Morton, M. Egbert, H. Hood, O. Moore, S. Hammons, Francis Paris, G. Carruthers, Capt. K. McKinnon, and advisor F. Aiken. Not shown are J. McKinnon, A. McKinnon, and J. Tucker. (Courtesy of the family of Willie Cunningham Paulk.)

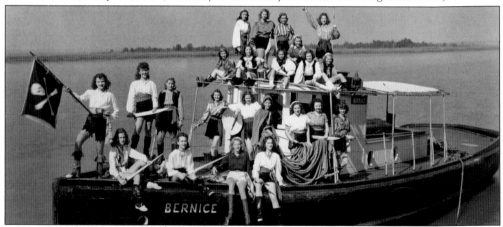

In this image dating from October 1940, the "Pirates" have taken over another vessel. Owned by Capt. Ed Royall, the *Bernice* was licensed for charter to take out pleasure parties and in June 1942 began war-time service with the U.S. Coast Guard as a security vessel and fireboat in the Brunswick harbor. Seated from left to right are C. Wolfe, V. Trobaugh, A. Huston, and B. Brown. Standing are M. Royal, J. Gillican, J. Huston, H. Blanton, A. Whittle, M. Tiller, C. Gould, B. Hughes, and C. Johnson. Seated in the upper row are A. Champion, D. Torras, W. Hopkins, M. Norton, F. Bright, and D. Kammerer. Standing above are B. Wood, M. Scarlett, B. Gayner, and P. Harper. (Photo by Harold J. Terhune; courtesy of James D. Gould III and Clara Marie Gould.)

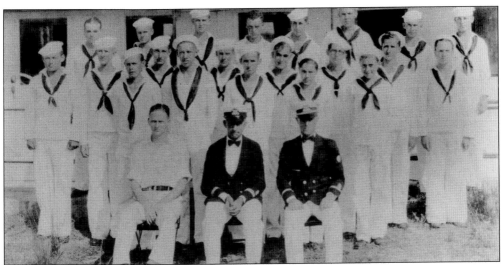

Designed as an "older boy program" under the auspices of the Boy Scouts of America, the Brunswick Sea Scouts were shepherded by "Skipper" Marion Leroy Burn of the Quarantine Station in the 1930s. Targeting young men of a minimum age of 15 years, the "Brunswick Ship" held distinction as one of the oldest in the nation according to former scout Joe "Dodie" Lambright. Along with his brother Ed, Lambright and other Brunswick boys gathered on Friday nights for instruction. Seated in front center is Skipper M.L. Burn, and to the right First Mate Wyche Jones; on the third row, second from left, is Billy Konetzko; on the fourth row, second from left, is Dodie Lambright; on the fourth row, first from right, is Jack Dent; and on the fourth row, second from right, is "Cowboy" Brockington. The Atlanta, Macon, and Brunswick Scouts assembled for a Cumberland cruise in 1931. (Courtesy of Ed Lambright.)

Members of the "Brunswick Ship" included Hubert Lang Jr., Dave Gould, Jack "Jug" Symons, John Browning, Billy Dunlop, Carroll "Q" Quarterman, Leo Ross, Tommy Powell, Andy Lorentzson, Vassa and Henry Cate, Jack Dent, Bob Brown, and Billy Konetzko. They met at the wet basin near the Hershey sugar docks for transport to Quarantine aboard a 25-foot motor launch, the USPHS *Porter*. In the disinfecting plant the young men learned maritime skills and developed character traits, such as how to be trustworthy, loyal, helpful, friendly, courteous, kind, obedient, cheerful, thrifty, brave, clean, and reverent. Pictured from left to right, Dodie Lambright, Billy Konetzko (1911–1967), and Jack Dent casually pose on the Quarantine Dock. (Courtesy of Ed Lambright.)

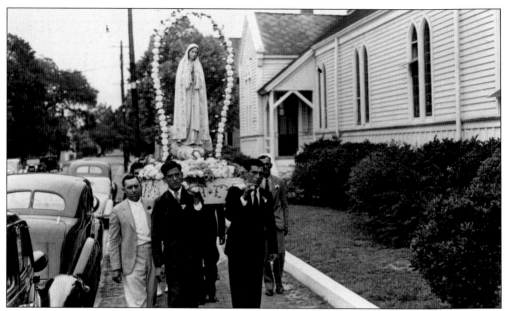

Beginning in the early 1920s, many Portuguese citizens moved from the inclement weather of Northern states down to the South. Bringing with them traditions that reflect an Old World charm, they have contributed to the rich fabric of the City by the Sea. In 1937, members of Brunswick's Portuguese Colony pooled resources and ordered a statue of Our Lady of Fatima. Made in Portugal and carved of one solid block of Brazilian cedar, Our Lady's presence represents one aspect of a devout commitment to the St. Francis Xavier Roman Catholic Church. The carriers of the statue were supervised by Manuel Boa (far left, dressed in white). (Courtesy of the Moreira family and Ethel Moreira.)

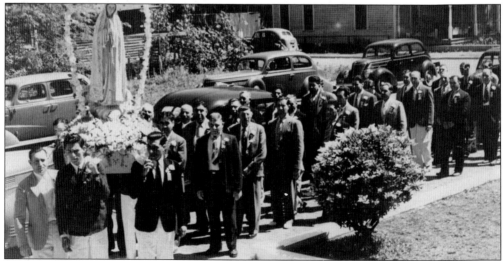

Formerly, all of the men were shrimp fishermen or shrimp dealers, and through hard work and successful harvests, these close-knit families perpetuated Old World traditions and sent their children to Catholic school. Through the years a Blessing of the Fleet has become associated with an early May Mother's Day commemoration. Heralding the opening of the shrimping season, festivities include religious and cultural activities. (Courtesy of the Moreira family and Ethel Moreira.)

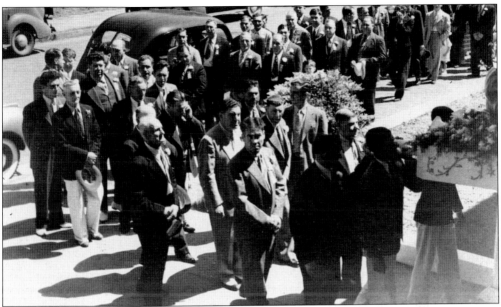

These images date from 1939 and the first procession of Our Lady of Fatima through Hanover Park and around the old St. Francis Xavier Church. While members of the Sodality of Our Lady prepared the church, some decorated her statue on a flower-decked platform. In the images, four boys carry Our Lady on their shoulders half way on the route and then four more boys complete the procession, as men of the Portuguese families follow. (Courtesy of the Moreira family and Ethel Moreira.)

Our Lady was painted white and blue, and her crown of gold signifies honor and respect for men lost in war, including Louis Romeira, Domingo Manita, and Eugene Cutinho. They died in patriotic service during World War II after this gathering had assembled. The little children shown above passed along not only established customs and beliefs but the memory of these patriots. John Mendes (far right) stands with the following children: Mary Lopes, Teresa Martin, Marie Spalding, Tony Cross, Rose Romeira, Olga Golino, Rosalind Fernandes, Edna Oliver, Joe and Mary Jo Cruz, and Joe Santos. (Courtesy of the Moreira family and Ethel Moreira.)

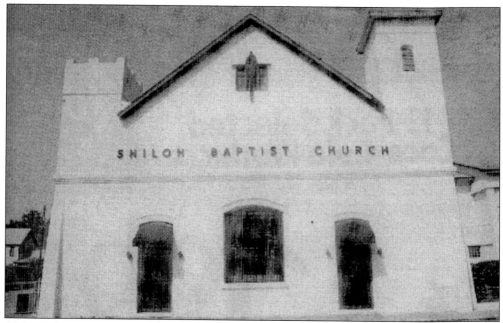

Chartered in 1873, this 96-year old church will be replaced through community and congregational support by a new Shiloh Baptist Church. Covering the 1200 block of Egmont Street and bordering the Glynn Academy campus, the sanctuary at Shiloh features 17 irreplaceable stained-glass windows, including a memorial window dedicated to Rev. S.C. Roberts. For 34 years Rev. Eugene C. Tillman has pastored, during which time the congregation has doubled to over 500 members. (Courtesy of Rev. E.C. Tillman.)

In 1995, the First Baptist Church celebrated its heritage and 140th anniversary. Constituted with 9 white and 70 black members in 1855, the congregation petitioned to join the Sunbury Association and, in 1869, reorganized and joined the New Sunbury Association. In 1892, the congregation was admitted to the Piedmont Association. This image shows an 1890s church, which was replaced after more than 70 years of service with the present sanctuary, designed by F. Arthur Hazard and dedicated on March 5, 1967. Through the years, an active First Baptist Church has sponsored mission churches whose communicants today worship at Norwich Street, Calvary, Blythe Island, Southside, and Jekyll Island Baptist Churches. (Courtesy of Charles E. Ragland.)

Organized on February 17, 1867, the sanctuary of the First Presbyterian Church was built on property donated by Urbanus Dart and dedicated on December 18, 1873. In 1874, First Presbyterian was admitted to the Savannah Presbytery. An educational building has enabled the congregation to offer outreach programs and support benevolent causes. The slogan "The Little Church with the Big Heart" carries forth the ministry and mission of its beginnings. (Courtesy of Rev. Greg A. Garis.)

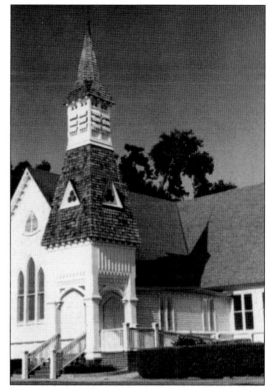

A group of parishioners organized in April 1858 and received Diocesan blessings the next month for St. Mark's Episcopal Church. Dating from the cornerstone laid in 1911, the present church represents an excellent example of 15th-century Medieval English architecture, and its location at Norwich and Gloucester Streets dominates a key north-south corridor. (Courtesy of St. Mark's Church historian, Virginia Hobson Hicks.)

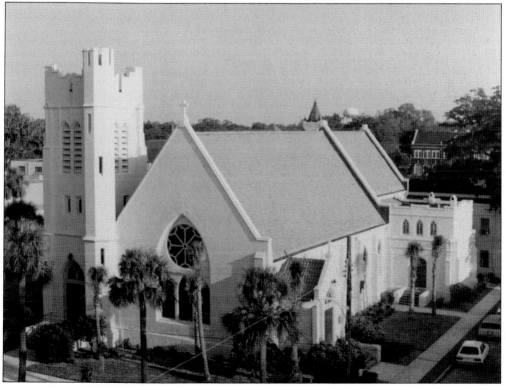

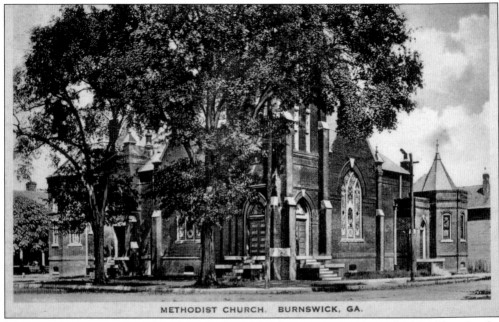

METHODIST CHURCH. BURNSWICK, GA.

A postcard captures an earlier image of Brunswick's First United Methodist Church; the congregation celebrated 157 years of ministry in 1995. Urbanus Dart donated lots bordering Blythe Square in 1854 where a wooden structure was constructed and replaced in 1907 with the completion of the present church, a fine example of high Victorian Gothic architecture. Hosting South Georgia Annual Conferences, sponsoring city missions, such as McKendree Methodist Church, expanding to meet congregational needs and organizing Brunswick's first Boy Scout troop in 1915 number are among the contributions of First Church. (Courtesy of E. Ralph Bufkin.)

A jubilee celebration in 1961 acknowledged a self-educated, self-made man David Glauber as the organizer of Temple Beth Tefilloh, which dates from 1886. Dedicated on Friday, November 7, 1890 and located at Monck and Egmont Streets, the Temple boasts members who are among Brunswick's most prominent citizens and who have contributed in a rich manner toward the city's vitality through their work as merchants, wholesale grocers, brewers, bankers, attorneys, and architects. Some of the earliest sacred art in the city features stained glass in a Ten Commandments window over the Ark inscribed in Hebrew and side windows of the Tribes of Israel. (Courtesy of Merriam A. Bass.)

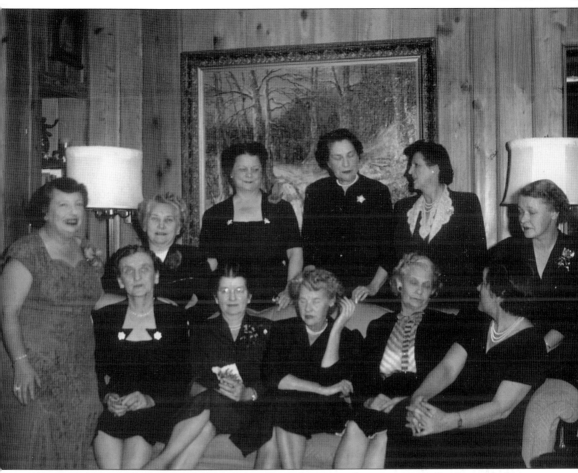

Charm and grace characterized the setting for gatherings of prominent and cultured ladies, members of Brunswick's social clubs. Organized in 1896, the Acacia Club held the distinction as the oldest social club in the state; it featured inherited membership and weekly meetings for a standard game of five-hand euchre. Another group was organized as the Friday Afternoon Club, and in the above image, members of the Amity Club have gathered at the Shelander home overlooking St. Simons Sound and Jekyll Island. From left to right are (front row) Selma Fendig Shelander, May Wright Parker, Kate McKay Fleming, Evelyn Williams Gowen, Lucy Newton Tiller, and Emwyn Neal Fendig; (back row) Mary Morgan Scarlett, Alice Harrison Aiken, Edith Gunnels Sherman, Emma Fox Gayner, and Polly Bowers Parker. Dating from October 1923 when three friends met in Louise Elliot McCrary's home and organized, the Amity Club gathered for dessert bridge and conversation each Friday. A hand-sized booklet gave a brief history and outlined five rules of the organization: club membership of only 13 elected by majority vote, Friday meetings, officers consisting of president and vice-president, and allowing house guests as guests of the club. (Courtesy of Polly Parker Kitchens.)

In the following four images, oversized posters advertise the evening fare offered by the Little Theatre of Brunswick when local talent brought Broadway to the City by the Sea. Dating from the Great Depression years, thespians entertained with comedy, mysteries, and drama, and by the late 1940s, an 8:30 p.m. curtain call—first at the old Airport Playhouse and later at 609 Grant Street in Brunswick. (Courtesy of Stephen King Hart.)

Reviewing *Blithe Spirit* in July 1948, author and poetess Margaret McGarvey admonished locals to cross the causeway and partake of the Georgia Players production and comedy by Noel Coward in which a medium, Madame Arcati, throws a family into a quandary. Described as "excellent theatre and wonderful entertainment," McGarvey opined on the comparison as "quite amiable" with the original New York production. (Courtesy of Stephen King Hart.)

Many years later, in Miss Mary McGarvey's *Coastal Illustrated* column, she told of "Midsummer Madness and how the Little Theatre of Brunswick languished and struggled after flaring tempers associated with the 1956 centennial pageant." Her maiden sisters, Margaret and Virginia, were charter LTB members. Margaret's role as secretary and reviewer for many years kept the name of the Little Theatre of Brunswick in front of the public, and Virginia's expertise was devoted to high-quality sets. (Courtesy of Stephen King Hart.)

After 1956, the Theatre continued with a spin-off of cabaret-style productions at the well-appointed King and Prince Hotel, and Brunswickians have starred in Hollywood productions such as the 1950s *The View from Pompey's Head* and 1970s *Conrack* with Jon Voight. Reminiscing, Miss Mary McGarvey remarked how "The theatre must have youth with its strength, energy, originality, talent and beauty, and young people were no longer interested in the legitimate theatre." She envisioned "Theatre again in Brunswick." (Courtesy of Stephen King Hart.)

In this image from October 1991, Bruce Faircloth (left) and cultural icon Miss Mary McGarvey discuss the role her sister Virginia played in organizing community concerts and bringing Carnegie Hall to Brunswick. Working in support of the Brunswick Community Concert Association and performances at the Memorial Auditorium, Virginia McGarvey was an active member from its beginnings in 1940 until her death. Other longstanding members include Louise P. Ringel, Louise Homans, and Shirley Altman, who has held numerous offices through the years. Offering at a minimum three to four concerts throughout the fall and winter seasons, the BCCA has featured, among others, Ferrante & Teicher, the Gershwin Concert Orchestra, the George Shearing Quintet, and more recently, Linda Wang on violin. When the Mattingly Memorial Fund was established in 1997, proceeds available to the executive and administrative board targeted audience development and student outreach programs thus assuring continued enthusiasm and support for the performing arts in the City by the Sea. (Courtesy of Bobby Haven/The *Brunswick News*.)

Bruce Faircloth's expression of delight and eager anticipation was captured in this image after notice of his election as the president of the BCCA, succeeding the Reverend Joe Walters. Faircloth has served multiple terms as president as well as being on the board of directors since 1951 (excepting a three-to-four-year hiatus due to challenging health concerns). A native of Douglas, Coffee County, Georgia, Faircloth was a familiar figure at 303 Mallory Street on St. Simons Island, where, for over 30 years prior to his retirement, he operated B.F. Custom Interiors. Working in support of the BCCA, his activities have ranged from executive positions to ironing costumes and sweeping floors to booking artists through Columbia Artist Management, Inc. in New York City. "Glynn County-Brunswick Community Concert Association, Inc. is a non-profit, educational outreach, civic organization," Faircloth enthused. (Courtesy of Bruce Faircloth and Bobby Haven/The *Brunswick News*.)

# BIBLIOGRAPHY

Abbot, William Wright. *The Royal Governors of Georgia, 1754–1775*. Chapel Hill, North Carolina: The University of North Carolina Press, 1959.

Bader, Jerry. *Official Program, Brunswick–Glynn County Centennial Celebration, August 13–18 1956*.

Bell, Laura Palmer. "A New Theory on the Plan of Savannah." *Georgia Historical Quarterly* 48(2): 147–165.

Bolton, Thaddeus Lincoln. *Genealogy of the Dart Family in America*. Philadelphia: Cooper Printing Company, 1927.

The *Brunswick News, Special Harbor Magazine*, October 1907.

Coleman, Kenneth. *Georgia History in Outline*. Athens: University of Georgia Press, 1960.

Conover, Richard E. *Give 'Em A John Robinson: A Documentary on the Old John Robinson Circus*. Xenia, Ohio: Richard E. Conover, Publisher, 1965.

Gayner, Dorothy N., ed. *Brunswick Area Bi-Centennial, 1771–1991*.

Ginn, Edwin H. *Recollections of Glynn*. Brunswick: Glover Printing Company, 1987.

Irvine, William S. *Brunswick and Glynn County, Georgia, To the Exporter, Importer, Investor, Manufacturer and Merchant. To the Fruit and Truck Grower, Stock-Raiser, Dairyman and Agriculturist. To the Health and Pleasure Seeker. Climate Unsurpassed*. The Board of Trade, Brunswick, Georgia, 1902.

Kimsey, Thora Olsen and Sonja Olsen Kinard (compiled & edited). *Memories from The Marshes of Glynn, World War II*. Decatur: Looking Glass Books, 1999.

McCash, June Hall. *The Jekyll Island Cottage Colony*. Athens: The University of Georgia Press, 1998.

Robinson, Gil. *Old Wagon Show Days*. Cincinnati, Ohio: Brockwell Company Publishers, 1925.

Symons, Howard Ray Jr. *Oak Grove "Lest We Forget."* N.d.

Vanstory, Burnette. *Georgia's Land of the Golden Isles*, New Edition. Athens: The University of Georgia Press, 1981.

Vicent, Ruth N. (Cassidy) and Sara Rogers Cassidy. *Palmetto Cemetery, Ross Road, Brunswick, Glynn County, Georgia*, 2nd Edition. Knoxville, Tennessee: Tennessee Valley Publishing, 2000.